Make-up
Techniques
FOR PHOTOGRAPHY

Cliff Hollenbeck
Nancy Hollenbeck

AMHERST MEDIA, INC. ◻ BUFFALO, NY

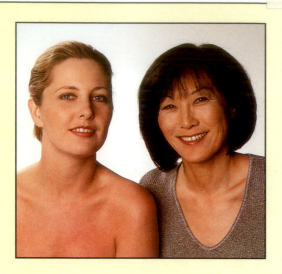

Acknowledgements

A special thank you to Omi, a talented make-up hair-stylist and designer, for her step-by-step make-up applications used in this book and on the cover. She can be reached at Skyline Studios in Seattle (206) 374-8840, via e-mail at <omi@skylinestudios.com> or visit her website at <www.omimakeup.com>.

A special thank you also to Regina Jones, a Milano, Italy-based model and actress, for participating in this book and other projects over the years. She can be reached at (773) 528-4727 in Chicago.

Copyright ©2001 by Cliff Hollenbeck and Nancy Hollenbeck
All photographs by the authors.
All rights reserved.

Published by:
Amherst Media, Inc.
P.O. Box 586
Buffalo, N.Y. 14226
Fax: 716-874-4508
www.AmherstMediaInc.com

Publisher: Craig Alesse
Senior Editor/Production Manager: Michelle Perkins
Assistant Editor: Barbara Lynch-Johnt
Copy Editor: Paul Grant

ISBN: 1-58428-037-9
Library of Congress Card Catalog Number: 00-132628

Printed in Korea.
10 9 8 7 6 5 4 3 2 1

TABLE OF CONTENTS

INTRODUCTION

☐ Photography and Make-up

This book is a basic guide to understanding and using make-up in photography. Everything we recommend or suggest is aimed at make-up for the camera's eye... not social situations. This publication is intended for photographers and models working together to create a beautiful face that will be photographed.

Over the past twenty years we have worked with and watched some excellent make-up professionals in action. While a few of their capabilities have rubbed off on us, if you'll forgive the pun, we are writing this guide as photographers, not expert make-up artists. There's a good reason they're called "Artists," because what they do is an art. We are presenting the basics of make-up, which you can also learn, as it is used in and around our photo and film work.

If you can learn and master the basic make-up information presented in this guide, then you can do well enough to work with just about any model in any situation. They will look good for your photography, which is the primary goal. Because make-up is a collaboration between models and photographers, some of the information is specifically aimed at one group or the other.

You will not become a professional make-up artist just by reading this book, but you will be able to talk intelligently with the best professionals and their top models.

We wish you good shooting.

—*Cliff and Nancy Hollenbeck*

"... make-up is a collaboration between models and photographers..."

☐ About the Authors

Cliff and Nancy Hollenbeck are a leading photography and film making team. They specialize in editorial and commercial image making throughout the world for major airlines, cruise lines, advertising agencies, magazines, book publishers and tourism associations.

The Hollenbecks have authored more than a dozen books on photography, travel and business subjects. Cliff has twice been named "Travel Photographer of the Year" by the Society of American Travel Writers. Their film company, which specializes in subjects similar to their still photography, has received gold medals at the International Film Festivals in Chicago and New York, as well as several Tellys for Travel and Tourism Sales Programs and Commercials.

1
MAKE-UP AND PHOTOGRAPHY

☐ The "Rules"

Throughout this book are many statements that sound a lot like hard and fast rules. They aren't. In most cases they are the opinions and suggestions of the authors, who have their own ideas and expectations of how a model and a photograph should look.

There is only one major "rule" in photography and make-up: the model should look the way the photographer, the client or the ultimate viewer wants her to look in the final picture. If the model looks good to you and has the appearance you are seeking in the final image, then quit applying make-up and start shooting.

Another good principle that is worth remembering is that an experienced make-up artist is almost always worth the cost. In the long run, a professional will save you time, money, and add to your final results.

☐ Knowledge Needed

Working with make-up is like working with a camera. It takes time, practice and learning from your mistakes—just to become proficient. A basic knowledge may be more than enough to work with most models. Most experienced models already know what make-up is required for them to look good in a variety of situations and fashions. A general knowledge may also be enough for a lifetime of producing great images with the help of professional make-up artists. It will certainly be enough for you to ask intelligent questions and direct make-up artists, models and lighting people.

"It takes time, practice and learning from your mistakes..."

"... make-up is one of the most important ingredients..."

☐ Make-up and the Photographer

Making someone look beautiful on camera requires more than just knowing how to light a scene properly, set up a pose, and which side of the model's face to photograph. It also means preparing your talent, and in some cases, creating or styling her face. The application and use of make-up is one of the most important ingredients to almost all people photographers (with the possible exceptions of photojournalists and travel or documentary shooters).

Many photographers have an eye for which colors match, how much shading a face needs, and when there is too much enhancement of such things as the eyes or lips. If you don't have this knowledge or ability, it can be learned by examining the published work of the best professionals, and of course through trial and error.

In the consideration and application of make-up, the single most important thing to keep in mind is the desired look in your ultimate photograph. Make-up should not be something that requires so much time and attention that the other technical and creative concerns of your image-making are overlooked. It's just one of the many requirements—like setting the lights, styling the fashions and making the test proofs.

If you find yourself spending more and more time on the application of make-up, enjoying it or not, then you need to step back and ask if this is more important to you than the picture-making itself. When it becomes more time-consuming than the actual shooting, you need to hire a professional make-up person—or become one yourself.

☐ Make-up and the Camera

There is a huge difference between looking good on the street or at a social gathering and looking good for the camera and in the eventual photographic image.

Every face, every fashion, every lighting set-up and every type of film reacts differently to make-up. Every model and actor has good, better and best looks, which may be enhanced with make-up.

Every photographer has lighting and shooting techniques that can improve on the best talent and make-up. The environmental factors of a shooting location will also play an important part in the type, amount and application of make-up that is used.

When all of these different elements come together in just the right manner and at the same time, the resulting photography should be spectacular.

☐ The Make-up Artist

Some make-up people are artists, just like photographers. They are artists because they are very good and very experienced at the art of make-up design, planning and application. It takes just as long to be a great make-up artist as it does to become a great photographer. Keep that in mind when you're dealing with a make-up artist, and when you're trying to help a model with her make-up. It isn't always as easy as it looks.

☐ Make-up and Shooting

Few great photographs just happen. They often take hours of planning, preparation, design, make-up, lighting and so on. Models and actors are frequently asked to perform before the camera, under hot lights or in less-than-desirable weather conditions, for long hours at a time. That's part of the job. That's what super-models get paid the big bucks for doing.

In addition to being tough on the people, these long hours and hot lights are also tough on the skin and make-up. Pay close attention to the clarity of your model's eyes and the make-up around them. This is where the strain and deterioration starts to show first. Give your talent plenty of cool drinking water and breaks during the shooting day—always more than you think necessary. Between set-ups, allow your models plenty of rest time in a comfortable setting.

> "Few great photographs just happen."

When make-up coordinates with the outfit, it makes a pleasing picture.

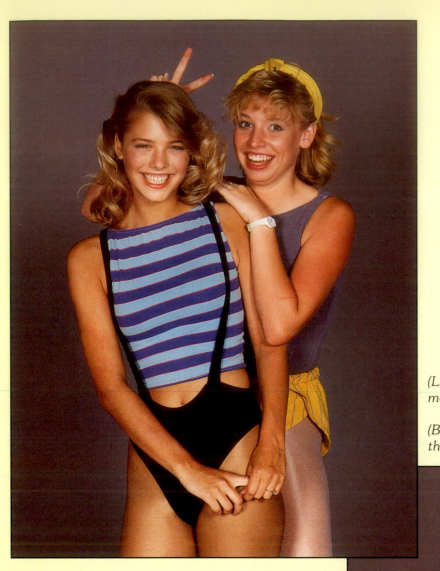

(Left) When working with more than one model, the models' make-up should compliment each other.

(Below) For images of healthy youth, use make-up that looks soft and natural.

2
THE FACE

While beauty is in the eye of the beholder, looking good in photography requires having a nice face that records well on film. Professional models have pretty faces. This is almost always the basic ingredient to their introduction and initial success as a model. A few are radiant, some gorgeous, and the best of the best are drop dead beautiful. All the make-up in the world won't change the need for this basic ingredient.

☐ Looking Good On Camera

Faces come in a thousand different combinations of sizes, shapes, colors, complexions, expressions—all with unique photographic possibilities. No matter how beautiful a face may seem at first glance, only the most natural ones seem to photograph well without being touched up for the lights and camera. In fact, some of the best known, most beautiful faces in the world (those of models, actresses and entertainers) look rather plain without a touch of make-up. Most of these beautiful faces wear little or no make-up when they are not in front of the camera or an audience.

The face is a canvas for the photographer and make-up artist. Looking good for the camera requires a combination of natural beauty, talent, make-up, lighting and creative cooperation between model and photographer. It also requires a little knowledge about faces on the part of the photographer, make-up artist and the model.

☐ Facial Structure

There is no "perfect face" for photography. There are only perfect faces and shapes for a specific look or product

"The face is a canvas for the photographer and make-up artist."

13

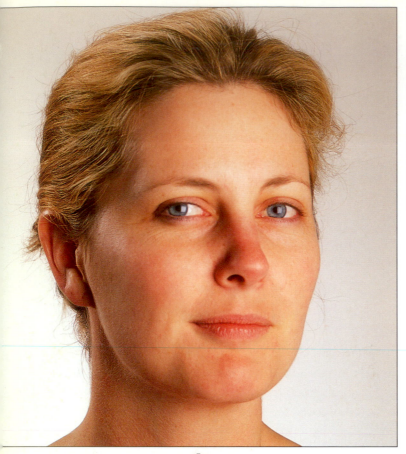

A

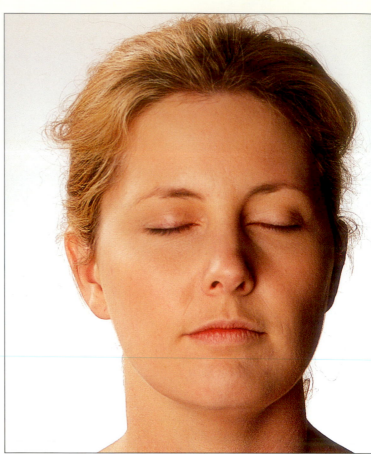

B

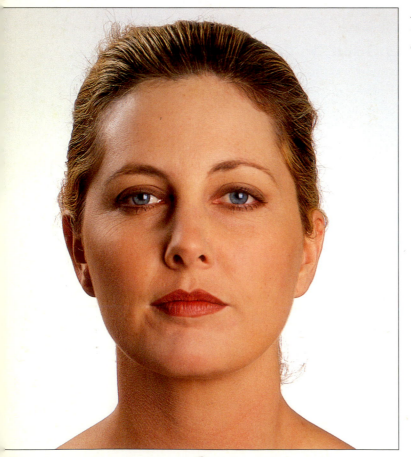

C

*A: Model with no make-up. B: Model with foundation only.
C: Model with natural-look make-up. (Opposite) Model with
evening-look make-up.*

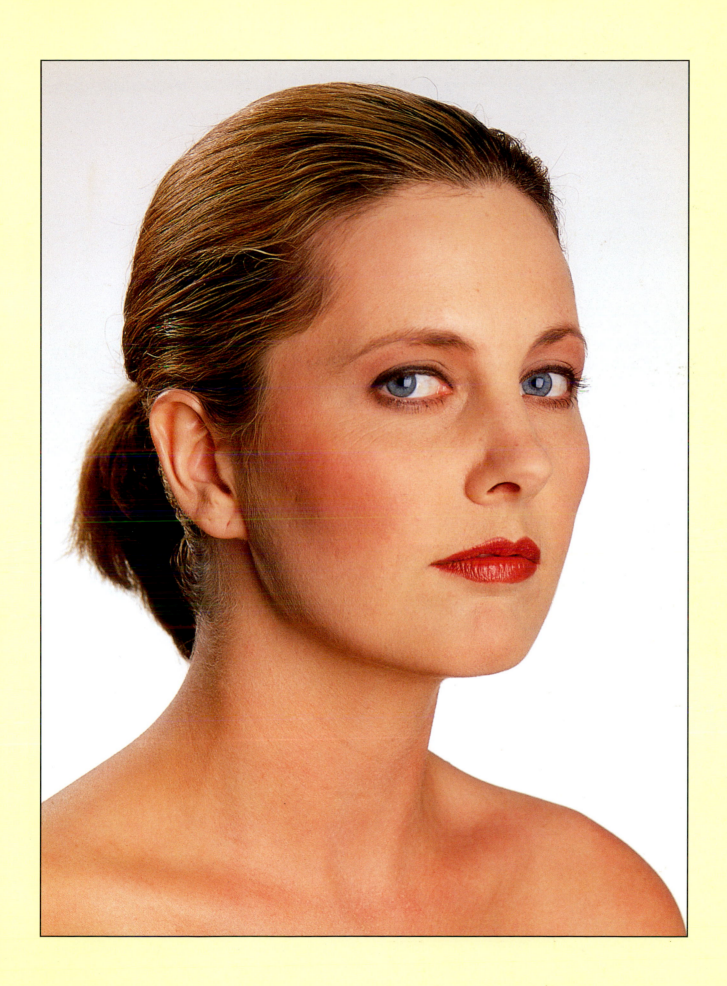

need. Of course, this will change with the times, fashions and current "in look" that is created by society and the media.

Faces come in about four basic shapes. They include: heart; round; square, and long. Each of these shapes has its own advantages in planning photography shoots. The shape, size and color of the product or prop will often determine the desired shape of a model's face. For example, a big round hat may work well with a longer face. Medium-sized hats look great on round and heart shaped faces. Delicate jewelry looks good on a square face. Big, clunky jewelry generally looks good on a longer face.

For the most part, determining which face shape is needed for a specific photographic set-up requires a lot of trial and error. An experienced model, make-up artist, stylist, photographer or modeling agency representative will usually know what works best. If you're planning a shoot and need a distinct face type, hair or eye color in a model, ask these people for suggestions.

The best place to learn about and see the wide variety of face structures is at a large talent agency. This can be done by looking at several models' "head sheets," which are examples of their work and a brief outline of their specialties and sizes. Agencies also offer extensive catalogs to the working professionals, where a photographer can see several faces and how they work in different lighting situations and locations. It is by far the single best resource you will use.

☐ Facial Features

A model's facial features play a very important part in the selection and make-up requirements for a photo shoot. This is where you need to know, or have some idea, what the final image is expected to look like. Is there a special facial characteristic or look you need for a shoot?

The most common request is for exaggerated facial features. This includes features such as wide eyes, big lips, high cheek bones, large brows and so forth. To some degree a model with general, or normal, facial features can be made-up and given some of these types of features.

☐ Photo Looks

In addition to facial features, it is typical to ask for certain looks in a model. Most of these looks are created through the artistic application of make-up, hairstyle and wardrobe. The most common looks requested include: natural; glamorous; dramatic; exotic; pixie; cute; innocent; sophisticated; business-like, and so on.

"... facial features play a very important part in make-up requirements..."

When you utilize a special look, facial shape or facial feature, keep an extra print or Polaroid® in a binder for future reference. This will help future make-up artists, models and clients alike in the planning and preparation of a photo shoot. This resource will also make it easier to show clients, designers, talent agencies and make-up artists exactly what you want to feature in a specific situation or photo shoot.

☐ Finding Good Faces

Again, the best way to find good faces is by visiting a modeling agency and examining several of their head sheets and portfolios. Because of the wide variety of models and photographers available in such portfolios, you will learn what shape faces work well in specific situations. It's also the best single source for finding experienced professional models.

Talent agencies produce a wide variety of catalogs, head sheets and other resources. They will almost always offer copies of these products to the working professional photographer to keep in his or her file. These materials will come in handy when searching for a certain look or face. Again, we can't stress enough how important this source will be to your work.

"... the best way to find good faces is by visiting a modeling agency..."

(Above) With a little powder and lipstick, you can create an image of the perfect little girl playing dress-up.

(Opposite) Children and make-up are a great combination. It takes extreme amounts of make-up to create a clown look.

3
THE SKIN

The model's skin is part of the canvas offered to the make-up artist and photographer for their creative efforts and final presentation in pictures. This basic canvas should be of the cleanest, clearest and highest quality possible. While proper skin care is important to everyone, it is critical for a model or actor who is constantly changing make-up and working under a variety of lighting and weather conditions. The information in this section is directed toward the model or actor, who must care for her own skin. The advice may also be useful for photographers who work with models on a regular basis.

☐ Care

Diet is the easiest way to develop clear and healthy skin. Eating a diet concentrated with fresh fruits and vegetables is the first step. Drink lots of pure water, and avoid carbonated, sugar-added drinks and fake fruit juice beverages. An occasional glass of wine might be good for the body, and attitude, but stronger alcohol isn't good for the face and skin. Avoid eating candy and sweets. Obviously, avoid anything that results in a rash or causes the skin to become flushed.

☐ Keep it Clean

Cleanliness is the way to keep facial skin healthy. Make-up, dirt from the air and pollution will clog the pores and often cause breakouts and acne. For this reason, it is also important not to wear make-up for long periods of time or overnight. Keep the skin clean whenever make-up is not required.

"Diet is the easiest way to develop clear and healthy skin."

It's a good idea to get into a daily routine of cleansing your skin—every morning and every evening, and of course, after every photo shoot. In addition, get into a twice-monthly routine of deep cleaning and exfoliating your skin. This helps keep the pores clean and improves the tone and clarity of the skin. Again, wear as little make-up as possible when not doing a photo shoot or socializing.

☐ Basic Skin Cleansing

Your photo shoot cleaning, and daily cleaning sessions should follow a simple pattern. First, use a cotton ball or pad and light make-up remover to remove heavier concentrations of oil and make-up, such as around the eyes or where

A: For daily or photo-shoot cleaning, gently lather the skin with a mild cleansing cream. B: Apply a little moisturizer afterwards.

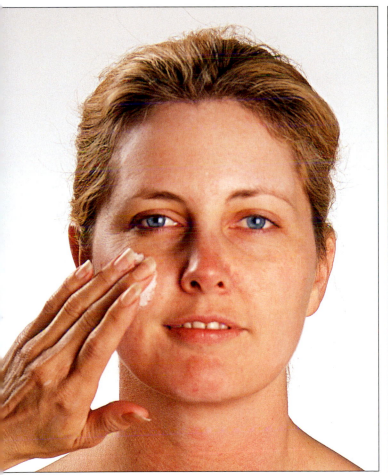

A

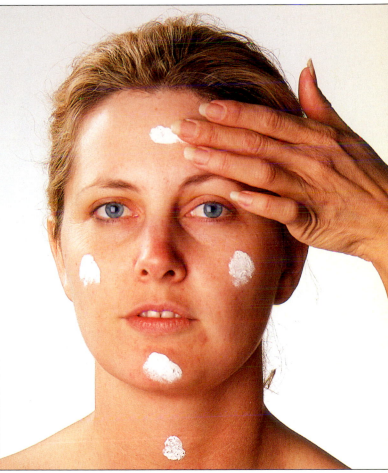

B

heavy foundation or concealer has been used. Be careful not to rub hard or pull the skin as you clean. Next, softly lather your face and neck generously with a mild cleansing bar or cream, and wipe off with a soft tissue (or rinse with water, according to the product instructions). Finish by applying a little moisturizer afterwards, especially to dry areas.

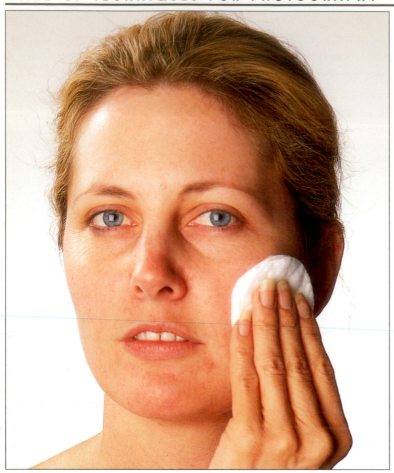

Using a toner helps to clean, balance and rejuvenate the skin.

☐ Deep Cleansing

The skin needs to be deeply and completely cleaned every two weeks or so, depending on the type of skin you have. Many good facial scrub or face mask products are available and should do the job. Ask friends, a knowledgeable salesperson or your dermatologist which manufacturer has the best products for your type of skin and sensitivity. Then, follow the product's instructions carefully.

Some people also like to give themselves a mini-facial sauna to open and clean out the pores. To do this, drape a towel over your head while holding your face about a foot above a bowl of very hot water (**do not** do this over a stove or actively boiling water). The towel over your head will trap the steam and warmth from the water near your skin. Five minutes under the towel should do the job. After your mini-facial, cleanse the skin lightly.

Models with oily skin, or skin that is prone to develop blackheads or clogged pores, might want to use a cleansing strip once a week. Produced by Ponds®, these strips can clear away unwanted grime and blackheads better than mild washing. Read and follow the instructions carefully.

"Get a comfortable seven to eight hours sleep every night."

☐ Get Some Sleep

Want to avoid big bags and circles under the eyes? Get a comfortable seven to eight hours sleep every night. If you party all night, your face will show it the next morning, unless you are very young. It will recover with a good night's sleep. If you party every night, in no time you'll look like your mother—or at least look old enough to be her sister instead of her daughter. You may never recover from this look.

If you have trouble getting to sleep, try taking a one-hour walk every day. This simple exercise will help clear your mind and keep your body in shape at the same time. Regular exercise has also been shown to contribute to restful sleep and overall health and well-being.

☐ The Environment

The environment (pollution, the sun, cold weather, sea water, etc.) can be extremely damaging to the skin. While it may be impossible to avoid all of these things, in many cases it's easy to reduce their effects.

Don't smoke, and stay away from smokers and smoke-filled places. Smoking will cause wrinkles around your mouth and eyes. Just being around smokers will cause the whites of your eyes to become yellow and bloodshot. According to the best authorities, smoking will also damage your lungs and make you old and dead before your time. You'll smell bad, too.

The sun can also damage your skin. Fortunately, there are many daily-wear make-up foundations and moisturizers that offer built-in sun protection. Talk with a professional make-up salesperson to find out what will work best for your skin. When you know you'll be in the sun, wearing a hat and sunglasses will also help prevent sun damage.

If you've been swimming, use fresh water and a cleanser to wash off saltwater and pool water as soon as you get out. You should also wear waterproof sunscreens when you'll be in or around the water.

Don't lay out in the sun to get a tan, and always wear a good sunscreen in the sun—in hot and cold weather alike. If you want the look of a tan, use a good artificial tan cream. These products have improved dramatically in recent years and offer a safe way to achieve a natural-looking tan. If you must have a real tan, use a skin-safe tanning bed.

☐ Skin Types

People are born with three basic types of skin: normal; dry, and oily. They are stuck with this for life. Most of the popular professional skin care and make-up products come

> "Wear a hat in the sun when possible."

in separate forms for each of the different skin types. While there are a few extreme cases, none of the three is generally better than the others for modeling or make-up. A good make-up sales person or artist can analyze your skin type, making it easier to purchase the correct products.

Normal Skin. Obviously, normal skin is neither dry nor oily. It's, as you would expect, somewhere in between and the most common type of skin. Most people with normal skin find they have places that are dry and flaky at times, and other places that seem oily at times. This mixture is also normal and sometimes called combination skin.

Oily Skin. Skin that looks a little shiny is considered oily. This type of skin needs just a little bit more cleansing and is more prone to pimples. Water based foundations and the use of powders are best for this type skin, to help eliminate some of the natural shine.

Dry Skin. Dry skin is just that—dry. It can be a little powdery or flaky at times, which is easy to correct, and is more prone to rashes than other skin types. Make-up artists say this type of skin will feel a little tight after washing.

What Type Skin? If you don't know which type of skin you have there's a simple test. Place a small half-inch piece of adhesive tape on the cheek and bridge of your nose (stay away from your eyes). Clear tape will do fine. Then, remove and examine the tape:

- Small drops of moisture mean oily skin.
- Small flakes of skin mean dry skin.
- Nothing or a little of both mean normal skin.
- Dirt spots mean you need a good cleansing.

☐ Skin Color

Most people know their basic skin color, be it fair, olive, brown, black or variations thereof. As with skin types, make-up and skin care products come in different types for each skin color. A good make-up salesperson or artist can analyze your skin color accurately, making it easier to purchase the correct products.

For foundation and concealer, the right make-up color should match your skin color and blend into your face. If it seems to vanish, then you have the right color. Remember to test make-up colors on the same skin on which you will be using the product, and under daylight conditions. For best results, face make-up shouldn't be tested on your hand.

The face and neck color of sun lovers will constantly be changing, as they get more or less tan. This means you will need several colors, from lighter to darker, which can be mixed to match your current shade.

"Skin that looks a little shiny is considered oily."

(Opposite) If the foundation seems to vanish on the model's skin, then you have the right color.

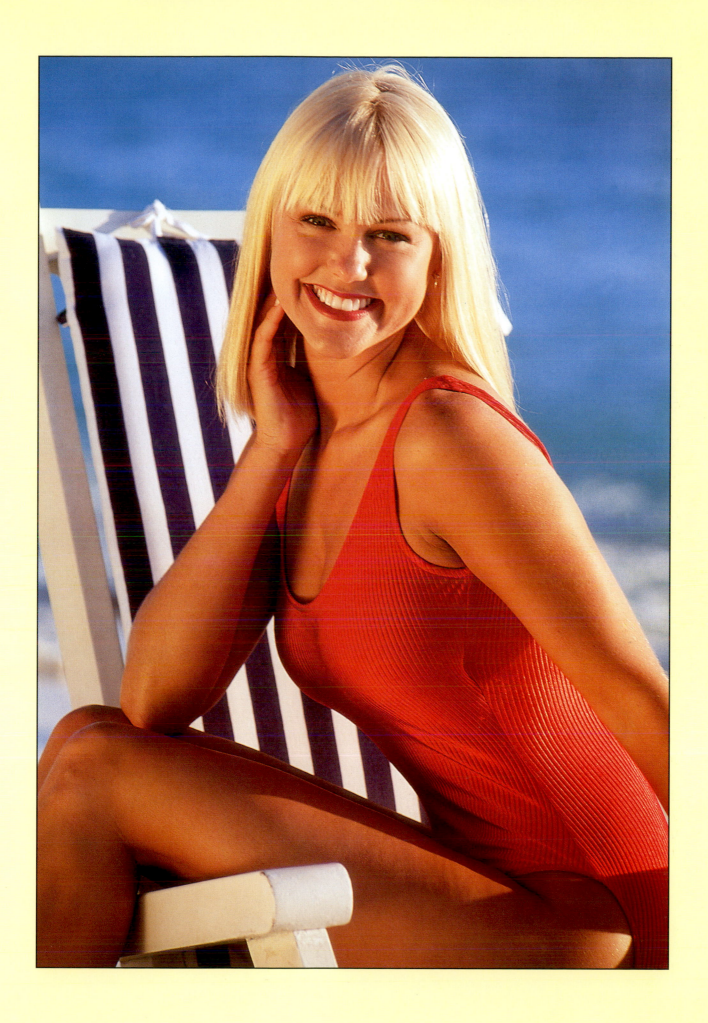

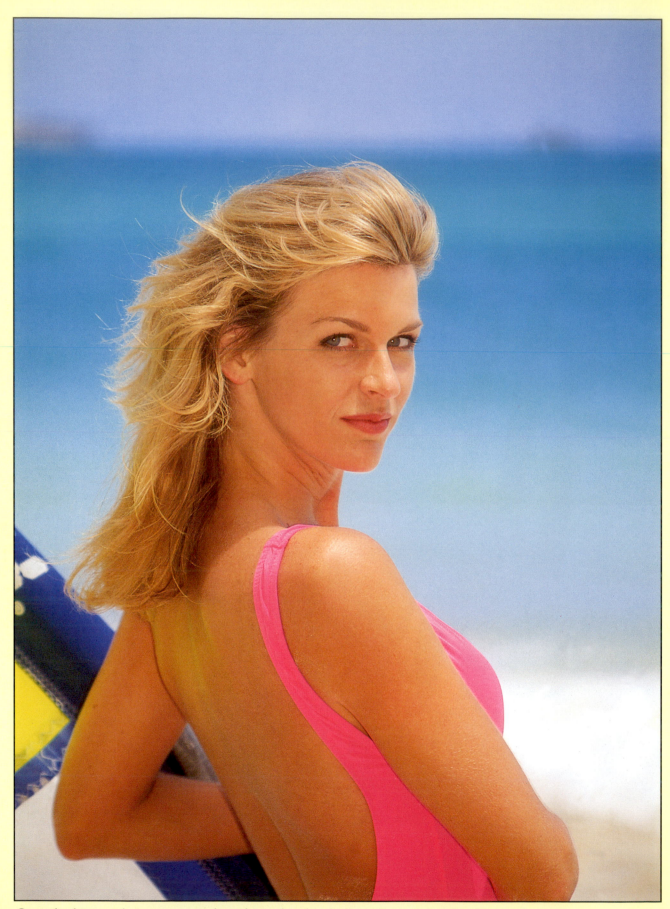

Great looking make-up starts with making the skin look its best—smooth, clear and even.

4
SKIN PROBLEMS

☐ Basic Problems

There are a variety of skin problems, including pimples, rashes, dryness and the like, which often come and go in even the healthiest skin. Many of these problems can be eliminated with proper advance care and nature's own healing processes. Scars, burns, birth marks, bruises and other more serious problems require some type of concealer or more serious action.

☐ Pimples

The most common skin problem is pimples. Perhaps this is because the majority of models are still at the age when skin is growing the fastest and is the most susceptible. In addition to your regular cleansing routine, use a good medicated cream. For immediate care of a really bad one, use a cotton swab and dab with fresh lemon juice. A concealer can partially hide pimples. Use one that is close to your skin tone or slightly lighter. You can even cover a single bad pimple with a spot of brown eye pencil, making it into a beauty mark. If it's on the middle of your nose, though, take the day off.

Prolonged and widespread pimples may be a sign of acne. If you have one of these skin problems, talk with a dermatologist regarding care, make-up and healing needs.

☐ Rashes

If you are prone to skin rashes, there are a wide variety of hypoallergenic make-up products and special medical formulas available. If you experience rashes and reactions to

"The most common skin problem is pimples."

27

make-up, soaps or foods on a regular basis, stop using the item.

When it comes to rashes, pimples and acne, do not assume that cleansing and skin care will eliminate the problem. Of course, clean skin and proper care will help, but it may be a medical problem. If the problem is persistent, regardless of the cleansing efforts and different make-up products, seek the advice and treatment of a professional medical dermatologist.

☐ Facial Hair

Facial hair does not look good in a photograph. There's little a model can do to stop the growth of facial hair, which is more prevalent with the use of birth control pills and age.

There are a few things a model can do to eliminate facial hair. The easiest and most comfortable option for fair skinned people is to use a good bleaching product. This won't work, however, if you have dark skin or dark hair. There are also a few good chemical cream hair removers, which seem to remove unwanted hair for a few weeks. Waxing and plucking by a professional usually does a good job too, but can cause irritation to the skin for a day or so.

The only sure way to eliminate unwanted facial hair is by electrolysis. Talk with a dermatologist and get his or her recommendation for a professional electrolysis specialist. It will be costly, but for professional models, this process is probably worth the money.

Whatever you do, do not shave off unwanted facial hair. It will grow back in a stubble that looks worse than the hair did in the first place. It will also be a never-ending process.

☐ Clean Skin

A good cleansing program may help eliminate or reduce some of the skin problems just mentioned. Talking with a dermatologist will also help. For tips on basic skin cleansing, refer to chapter three.

☐ Serious Marks

Scars, burns and birthmarks can often be covered with a layer of two of concealer. If you have one of these marks, serious wrinkles, unwanted hair, eye bags or an undesired nose shape and modeling or acting is your career, you may want to make a more permanent change. This means you need to talk with a cosmetic or plastic surgeon. These sciences have advanced to the point where doctors perform what seem to be modern miracles.

"A good cleansing program may help eliminate or reduce some skin problems..."

The courts have ruled in favor of professional models and actors, so we're told, allowing that such operations (including some body enhancements) are a normal and necessary part of the business. That means they may be tax deductible.

When it comes to any medical procedure, don't take any unnecessary risks. Ask around for recommendations and always go to the most experienced doctor. Talk with your family doctor first. It's also a good idea to check with a Certified Public Accountant (CPA) regarding any unusual tax deductions for a modeling or photography business.

Keeping skin in good condition requires regular cleansing and careful attention to avoid environmental damage.

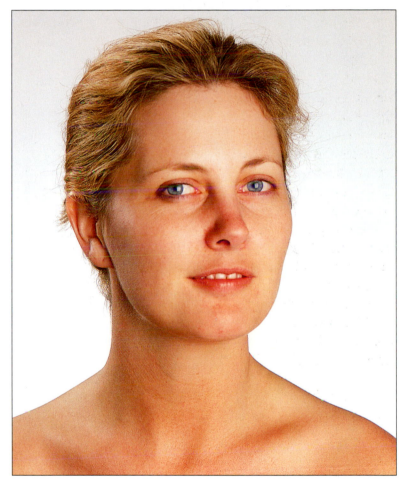

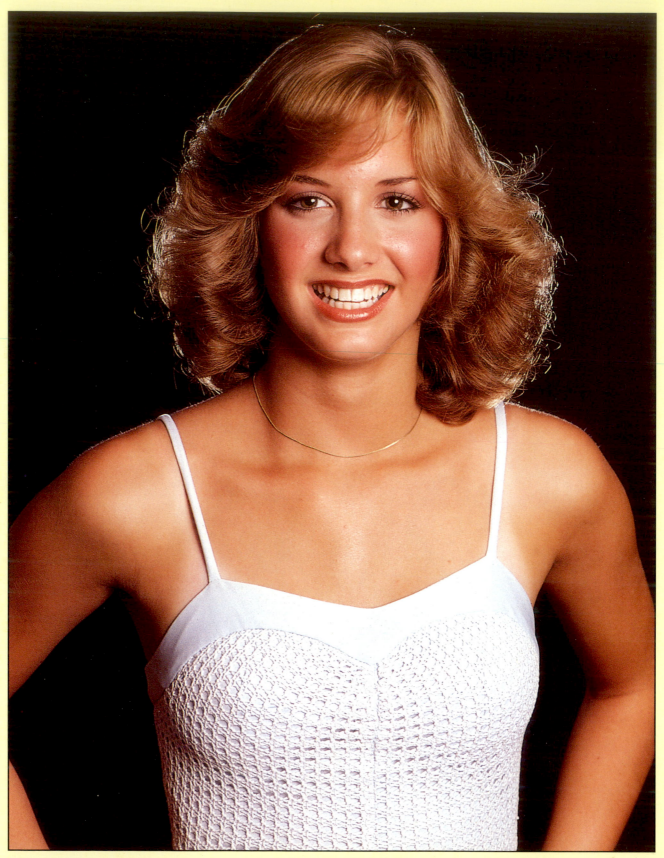

(Above) Heavier make-up and strong studio lighting can be hard on any skin type.

(Opposite) Natural light and a minimum amount of make-up is not only easier on the skin, but it makes a very appealing picture.

5
MAKE-UP KIT

Having the correct basic cleaning, application equipment and supplies is essential. It's equally as important as applying the make-up. These tools come in a variety of qualities, quantities and prices. While there are thousands of possible combinations, we've narrowed things down to the necessary basics.

☐ Tools

A good basic make-up kit will contain the following items:

- **Clips**
 Hair clips, bobby pins and ponytail holders are used to keep the model's hair out of the make-up application process.
- **Hand Mirror**
 Used to let the model see and assist with the application of make-up.
- **Working Mirror**
 This should include a hanger and stand. Battery powered lights are handy, too.
- **Scissors**
 Used for trimming eyebrows, nose hair, etc.
- **Powder Brushes**
 Look for soft brushes in large and medium sizes. Quality art brushes will work well with most powders.
- **Powder Puffs**
 Select powder puffs that are soft and disposable. Choose several sizes.

"These tools come in a variety of qualities, quantities and prices."

- **Eye Shadow Brushes**

 Select a range of small, medium and large brushes with medium-length bristles.

- **Eye Liner Brush**

 Look for one small and one medium brush, each with firm bristles.

- **Eye Brow Brush and Comb**

 Select a medium-soft brush with a small comb attached.

- **Lip Brushes**

 Choose one tapered brush and one flat tipped.

- **Blush Brush**

 Your blush brush should be full, soft and fluffy.

- **Toothbrush**

 You'll find all sorts of uses for a soft toothbrush in your make-up kit.

- **Sharpener**

 Used for eyebrow and lip pencils.

- **Tweezers**

 Select an angle-tipped pair for plucking eyebrows and removing stray hairs.

- **Eyelash Curler**

 Select the standard type.

- **Nail Cutter and File**

 Useful when the model's hands will be visible.

- **Tissues**

 Select tissues which are soft, colorless, unscented and double-layered. These are good for cleansing and tool clean up.

- **Cotton Balls**

 Use white medical or make-up 100% cotton balls.

- **Cotton Swabs**

 Select both small and larger sizes.

- **Cotton Pads**

 Purchase both small and medium pads.

- **Sponges**

 Triangle shaped sponges work well. Select the best quality possible.

- **Flashlight**

 A small spot flashlight is helpful when light is low.

> "Select an angle-tipped pair for plucking eyebrows..."

☐ Supplies

Find a good professional skin care and make-up supply house. Get their catalogs and visit the store for advice, equipment and supplies. Buy the best you can afford. Take good care of your equipment and it will last for years.

Make-up products don't last forever, rarely more than a few months. Keeping your supplies in a cool and dry place

will maximize their longevity. It is important to check both the quality and quantity of your supplies on a regular basis— usually right after every photo shoot. Replace the materials that are going bad, smell, are dirty or are changing color. It is far better to toss out bad supplies than to lose valuable shooting time sending out for replacements.

☐ Cosmetic Cases

Make-up artists use as many different working cases as there are different types of make-up.

For studio use, a good hard case with double locking snaps, lots of compartments, and plenty of extra room is best. Professional make-up supply houses have dozens of cases from which to select. Get one a little larger than you think is necessary—it will soon be overflowing.

For location shoots, select a traveling case that is soft, easy to pack and large enough to carry all of the essential tools and supplies.

☐ The Cleansing Kit

The basic elements of a good make-up cleansing kit include:

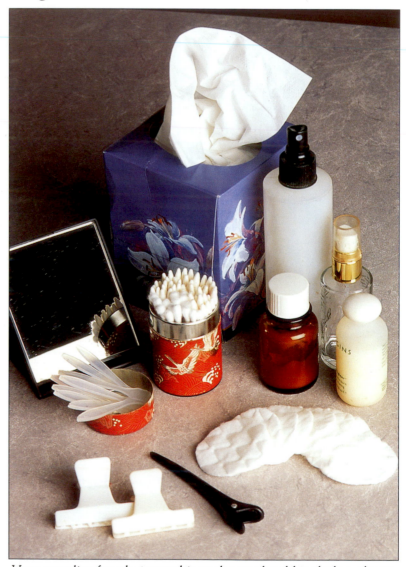

- **Cleanser**
 This includes cream, cleansing milk, lotion or cleansing bar.
- **Make-up Remover**
 Look for make-up removing liquid and pre-made pads.
- **Eye-Makeup Remover**
 This product is required for removing cosmetics from the sensitive eye skin.
- **Tissues**
 Select soft, colorless, unscented and double layered tissues.
- **Cotton Balls**
 Choose white, medical or make-up, 100% natural cotton balls.
- **Cotton Swabs**
 Supply both small and larger sizes.
- **Cleansing Brush**
 A cleansing brush should have soft bristles, and be no larger around than a silver dollar.

Your supplies for photographic make-up should include a cleansing kit.

- **Moisturizer**
 Used to protect and soften clean skin.
- **Soft Plastic Bag**
 For storage of cleansing supplies.

☐ First Aid & Health Kit

Always keep a first aid and health kit handy (perhaps in the bottom of the your make-up kit). Make sure you know how to use it well. You never know when a quick Band Aid® or antacid will keep a photo shoot moving, instead of stopping everything while someone runs for help. Several types of first aid and health kits are available at drugstores, camping supply houses and recreational outlets. Better yet, assemble your own more complete kit. Here are some suggestions for a basic kit:

first aid manual	**matches**
Ace® bandages (medium and large)	**nasal spray**
	safety pins
alcohol cleanser pads	**scissors**
Alka Seltzer®	**snake bite kit**
antacid	**soap (cleansing) and towel**
antibiotic ointment	
aspirin	**splint board**
Band Aids® (assorted)	**sunburn treatment**
bee sting ointment	**sun block**
antihistamine	**surgical gloves**
Calamine anti-itch lotion	**surgical knife**
cold pack (instant)	**tape (assorted)**
eye drops	**topical cut treatment**
gauze pads (assorted)	**triangular sling**
gauze roll	**tweezers**
hot pack (instant)	**soft plastic waterproof case**
insect sting treatment	

6

MAKE-UP AND THE FACE

☐ Applying Makeup

Before applying any make-up to a model, or yourself, make sure the basic tools are at hand. Select an open place to work, a comfortable model chair, lots of light and a good-sized mirror. Your make-up kit should be at hand level, preferably with the application tools nicely spread on a towel-covered table. Cover your model's shoulders, and wardrobe, with a large towel. Clip the hair back. Make sure the face is clean, dry and free of make-up. Make sure the model's eyes are clear, because it's easier to add eye drops before make-up is applied.

☐ Foundation

Foundation is a great starting base for adding other make-up applications. Powder is also good, as is a clean and dry face. Experienced make-up artists use all of these elements as their starting point.

Before starting with any base, ask the model if she regularly uses foundations, moisturizers and/or powders as her make-up base. Your model may already know what works best for her particular face.

Applying too much foundation will make the face look fake, or too made-up, so proceed lightly.

Application. The best way to apply foundation is with a small or medium sponge. These can be used either dry or slightly damp, and offer the easiest and cleanest method of application. Make-up sponges are also cheap enough to be thrown away at the end of every session, making them economical and sanitary. Models always appreciate your using

"Foundation is a great starting base for adding other make-up applications."

bright, clean, new sponges. We've seen make-up artists use their clean fingers to apply foundations and moisturizers. However, this may not be practical for someone who must also handle optical equipment, or where cleanup facilities aren't available.

Step One: Using a make-up sponge, start with a small amount of foundation, blending as you go.

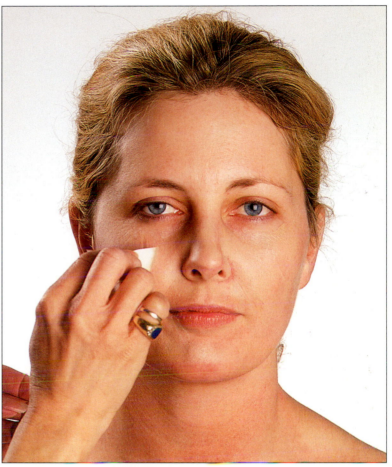

"If it's too thick, mix a little moisturizer into the foundation."

Start with a small amount of foundation, spreading it slowly and blending as you go. If it's too thick, mix a little moisturizer into the foundation. If you use too much foundation, the face will look fake—or like it's covered with a thin mask. This look isn't good for photography or social encounters. If this occurs, remove the excess foundation with a clean sponge.

Apply the foundation to the face, under the chin and on the neck, so that everything blends together and looks the same. The key to applying foundation and concealer is to blend, blend, and blend some more. Remember that the neck and chin should match the face. This may require using more than one color of foundation for models who use sunscreens on the face but not the neck. Apply the same blending process to the eyelids, even if shadow will be added later. The final color should look natural and clean, not like a powdered mask.

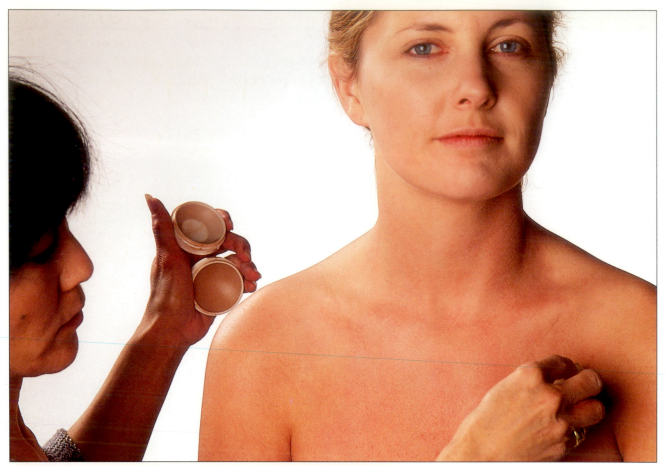

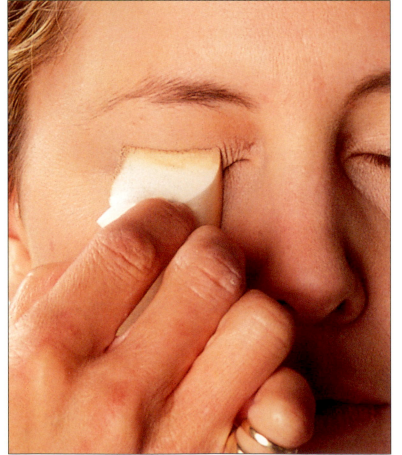

Step Two (above): Apply foundation to the neck (and if applicable, the upper chest), making sure it matches the tone of the face.

Step Three (left): Apply foundation to the upper eyelids (even if eye make-up will be applied later).

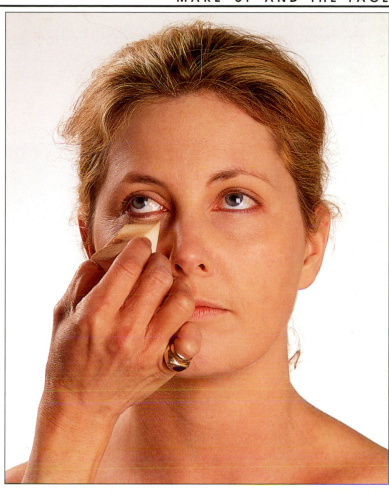

Step Four: Apply foundation to the area under the eye to conceal dark circles or puffiness.

Do not use foundation or concealer to shade or highlight the face into a special shape unless a special look is required. A soft color blusher is better for shaping the face and adding color. Highlights can be brought out with photo lighting (this works best with oil-based make-up).

When the application is complete, immediately set the foundation with a powder. This prevents the formation of wrinkles and creases. This step is essential for working under hot photography or film lights.

□ Concealer

Most models and photographers are more concerned with covering problem areas, pimples and other marks, than they are with any other part of the make-up process.

Types of Concealer. There are several types of concealer, divided into groups by their means of application. Each type has its own special use:

• **Wand**

Best used for tiny spots, like pimples. Be sure to blend with the surrounding skin color.

"... too much will make the face look overly made-up, or fake."

- **Stick**

 Applies just like lipstick, directly on larger spots or areas. Blend carefully. Do not use under the eyes, because the skin is too thin and sensitive for dragging the applicator across.

- **Compact**

 Comes in soft cream and powers, and is easily applied with a sponge or finger. Blend as you apply. This works well under the eyes.

- **Tube**

 Softer than the creams and sometimes more oily. Can be applied with a finger or sponge.

Concealers come in both water- and oil-based types. The drier, powder ones stay on the skin a little better. The soft creams are slippery, especially when applied to oily skin. The creams do work well, however, on the soft skin under the eyes.

Application. If you need to cover a problem area, try a second layer of foundation first. Sometime this will be enough. If not, add a small amount of concealer and blend

Step Five: Apply concealer to problem areas (left). Start with a slightly darker tone and blend with a sponge (right) to match the lighter foundation in order to avoid creating light spots which will show up on film.

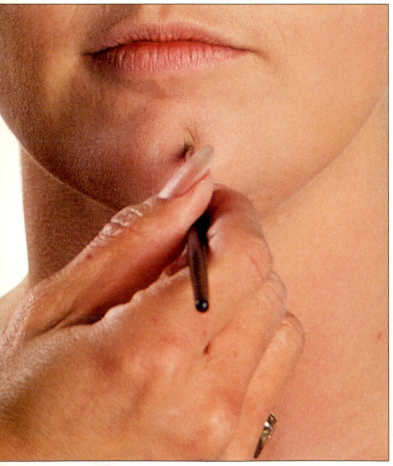
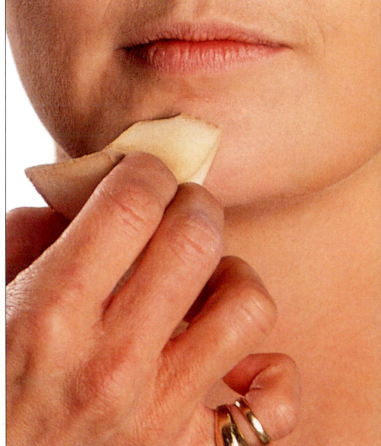

over the area. Again, if this doesn't work, add a layer of concealer and blend until it looks natural.

Concealer is not transparent, and too much will make the face look overly made-up, or fake. It will also exaggerate lines in and around the face. Try for a natural look first, unless there is some reason another look is required. White and light colors show up under photo lights, so start with a slightly darker shade and work toward the light or skin match. This is especially true with puffy or bruised skin.

Again, immediately set the final application (a second time) with a powder so wrinkles and creases can't form.

☐ Blusher

Shape and color can be given to the face by lightly brushing a little blusher onto the cheekbones. A heavier application may be important to a photography situation that is meant to emphasize a certain part or shape of the model's face. It will almost always look better on camera than at a social function.

Blusher should be blended to remove any hard lines. For normal photo setups, it should look like the model is slightly blushing with a soft glow to her face. The full-on flushed look does not photograph well in color. The final look should be a healthy glow, unless the face is being shaped or contoured with blusher.

Types and Colors. Blusher comes in several forms. Powders and creams are the best. Avoid liquid or jelled blushers, which are very difficult to apply. Do not mix blusher powders with other make-up creams, or blusher creams with other make-up powders. Use powder blushers on a dry face, cream blushers on a moist face.

While there are dozens of blusher colors, it's best to select something that looks natural. A color that is close to or lighter than the model's lipstick will normally work best. In fact, some make-up artists use a light dab of lipstick as a matching blusher.

Models who will be photographed with natural color lips should use the warm colors, like a brown or off-pink that matches their skin color. A light touch of blusher sometimes works better on the eyes than the heavier eyeshadow colors.

Odd blusher colors only look good in special situations. If it has a strange name and doesn't resemble any skin color you've ever seen, or want to be seen with, it's probably best to select something else. The odd blusher colors are good for costume and Halloween parties, but not much help with general photo sessions.

"Avoid liquid or jelled blushers, which are very difficult to apply."

Application. Use blusher sparingly, unless an exaggerated look is desired. For most set-ups, this means adding a warm, healthy look. Lighter is generally better. This can be accomplished by brushing a little blusher onto the cheekbones with a soft brush. Use a soft circular motion from the center of the cheekbone out. Blend as you apply, leaving no lines or obvious color spots.

When you have completed applying the blusher, step back and examine the model's entire face. If you are satisfied with the results, a light dusting of powder will set the blusher and slightly reduce the brightness of the color.

Step Six: Apply blusher lightly to the cheeks and blend carefully.

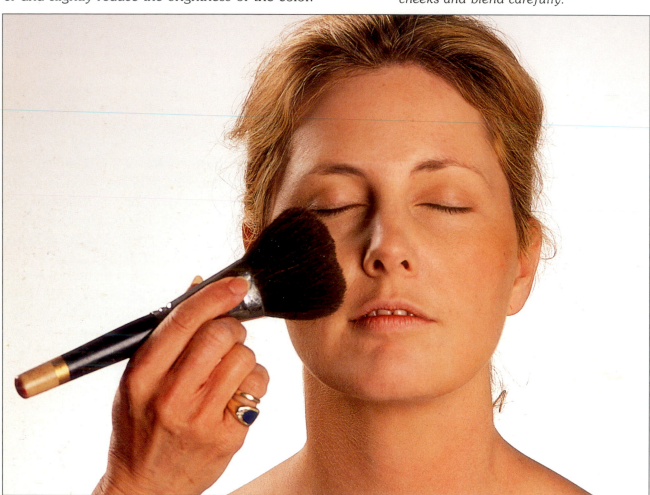

☐ Contouring the Face

Blusher, shaders and highlighters can be used to help shape the face, making a round face appear longer or a long face seem rounder. Remember that blusher adds a color that is brighter than the face's natural color and should be used sparingly. It's also important to note that contouring the face with blusher may work in a photograph, but will look like a bad make-up job in social situations.

☐ Shaders and Highlighters

Shaders and highlighters are obvious additions, used for making changes and contouring the face. In photography, they are used to show off or play down a certain feature on a model. They are more common on amateur models, unless a special look is desired.

Shaders and highlighters work best under more dramatic, subdued or natural types of lighting, rather than the full daylight look. They also seem to photograph very well in black and white film situations.

Go very light with this type of make-up and test the application and effect well in advance of a final photo shoot. The few professional models who need contouring, or other highlight shape changes know it, and know how it is best accomplished on their face.

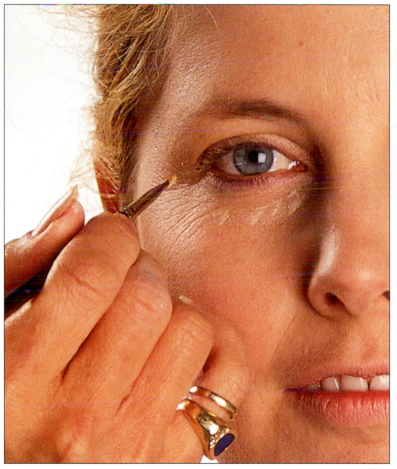

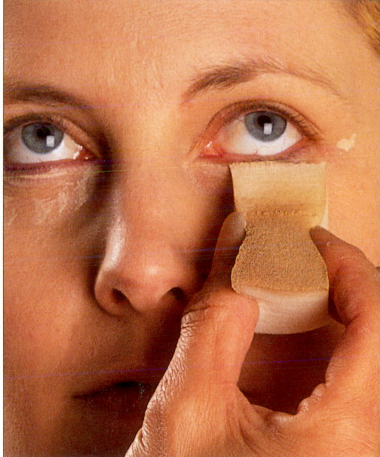

Step Seven: Use a brush to apply highlighter or shader as needed (left), then blend carefully with a sponge (right).

Shaders. Shaders are usually a powder that is darker than the skin. Sometimes a soft, natural blusher can be used to accomplish the same effect.

To slim down a nose, apply a little shader along both sides and blend with a small sponge. The same effect can be used for an uneven nose, applying shader mostly on the out-

For evening make-up, additional contouring and blusher may be desirable.

ward side of a bend. Unusual and bright colors will not work for this type of shading, unless you want the model to have a bright red nose.

Cheekbones can be made to look higher by adding a little shader in the hollows below the cheeks. Blend toward the hairline. Sometimes a little natural or soft color blusher can also accomplish this look.

A double chin can be reduced by blending a little shader beneath the chin and around the jaw line. Go light, or it will look more like unwanted hair or dirt. Even very slim models can have a double chin look when their head is pointed down toward the camera. Check yourself in front of a mirror or a home video camera to see which angles cause you to have a double chin. Blusher won't do a very satisfactory job in this situation.

When using shader, it's best to start with a light application, blend, and then add more as needed. Set the final look with powder.

Highlighters. A light-colored powder is generally used to show off the model's best features. Sometimes a light shade of eyeshadow will do the job as well.

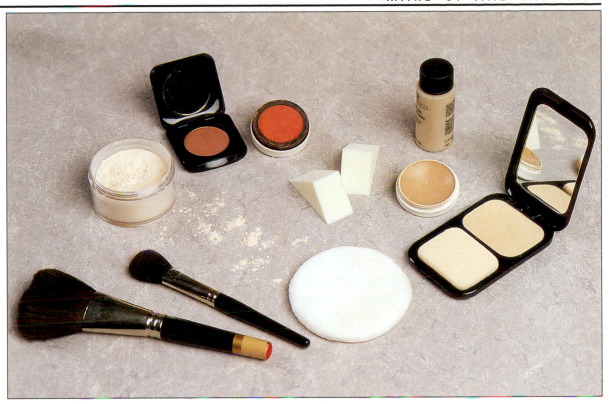

Make-up tools and products for the face.

To draw attention to the eyes, apply a little highlighter to the area just below the eyebrows and blend in.

The cheekbones can be emphasized by applying highlighter just above the primary cheekbones. Blend it in evenly up toward the hairline. Lighter or white blushers work very well for this type of look.

Lips can be emphasized, even somewhat enlarged, by applying highlighter into the dimple above the top lip and blending. Be careful with the lips, because too much of an emphasis will give the face a more bizarre look, which the camera will in turn emphasize to an even greater extent.

☐ Powders

Powders are used to set foundation and concealers and are a must in make-up for photographic situations. They also reduce the shiny look of oil-based make-up and the gloss of oily skin. Photographers can use powders to eliminate shine that may not be seen until the bright lights hit the face for the first time.

Some models (the very few with near-perfect skin) use power instead of foundation. It gives a slightly different matte, or non-glossy look, which may be desirable for certain photo situations.

Types of Powders. Powders come in loose, pressed and wet-dry forms. Most people use the loose powder,

applying it with a soft powder puff and then blending. The wet-dry powder is used when a heavier coverage is needed— or by those models who use it as a foundation. For the most part, they are all the same and your selection should be based on what works best for you or your model.

Powders also come in a variety of colors. For best results, set make-up with a powder that's slightly lighter than the foundation or skin. When no foundation is used, select a powder that matches the skin color.

Powders are also used by location photographers to set finished make-up applications. This will give an added protection against the elements and the strong highlights caused by sunlight or harsh reflections.

Application. Before applying powder, make sure everything is exactly the way you want it in the final photo. Applying powder will set the make-up, requiring complete removal if a mistake has been made.

Also make sure that the model's face is dry, blotting it with a soft tissue if necessary, before adding powder. As with all make-up application, less is always the best way to start. Lightly press and roll on with a powder puff. For very light applications, use a make-up sponge. Blend the powder lightly and evenly, so the skin doesn't look irregular.

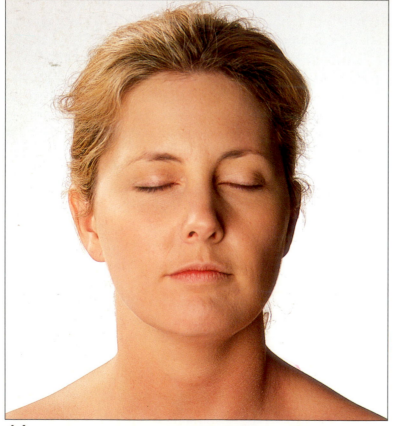

Step Eight: Adding a powder that is slightly lighter than the foundation or skin tone sets the make-up. Blend it carefully so the skin looks smooth and even.

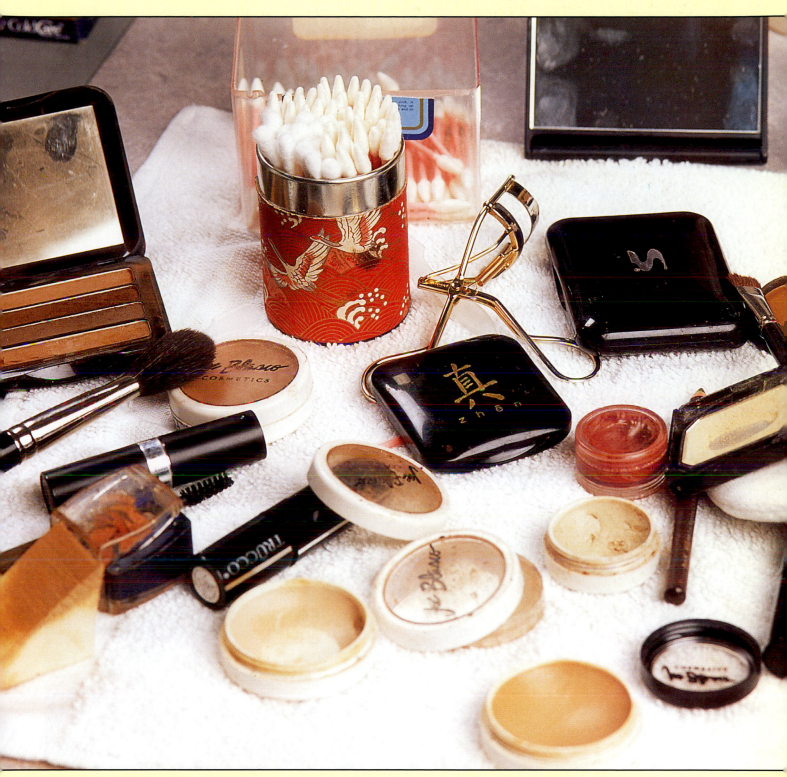

Before beginning to apply make-up, unpack your make-up kit and arrange the needed materials on a clean towel. Everything should be easy to reach and at hand-height.

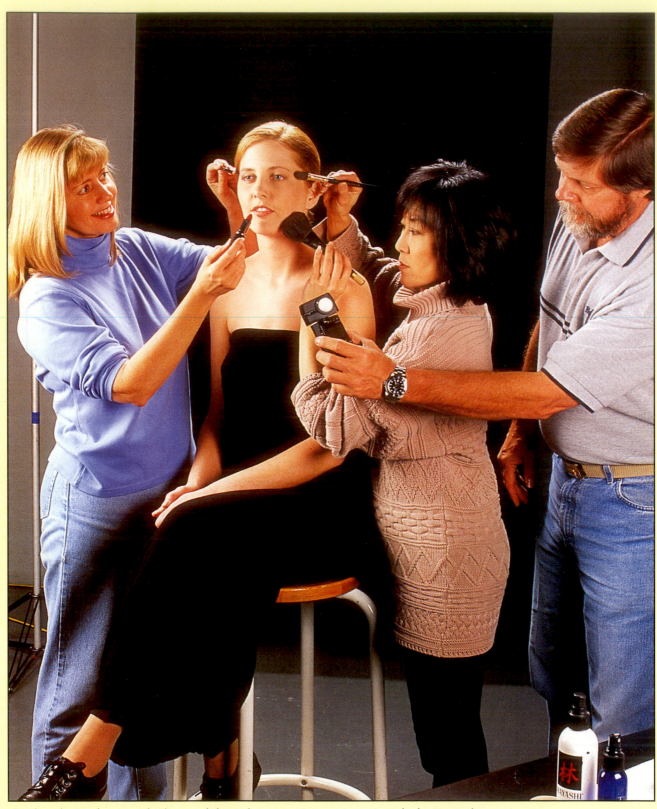

At the photo shoot with the model, make-up artist, assistant and photographer.

7
MAKE-UP
AND THE LIPS

Lips come in all sorts of sizes and shapes, just like faces. They can be made-up as the bright spot on a face, or a soft natural added attraction. Along with the eyes, the lips are what the camera sees first.

☐ Lip Colors

There are thousands of different lip colors available. Just look at the selection in your local drugstore alone. Without a doubt, there are enough colors and shades available that any set of eyes, any fashion statement and any clothing color can be easily matched or complemented.

☐ Choosing Lip Colors

Most experienced models advise to "go natural" (neutral medium tone) or "go bright" (intense tone) when in doubt. This advice might be great for social situations. In a photograph, however, the lips often determine the perspective or attitude of the final image. This is true even when the product or subject is something else entirely. With too much or too little lips, the final photo might fail—or worse, the product may never be noticed. It is important that you always step back and examine the overall face and situation to see if the model's lips balance or compete with the photo's other needs.

A good make-up kit will have several different color choices available, often purchased specifically for a photo shoot. Depending on how many shoots a make-up kit sees in a year, your kit could end up with dozens of different colors. This is one area where variety is needed.

"... lips often determine the perspective or attitude of the final image."

49

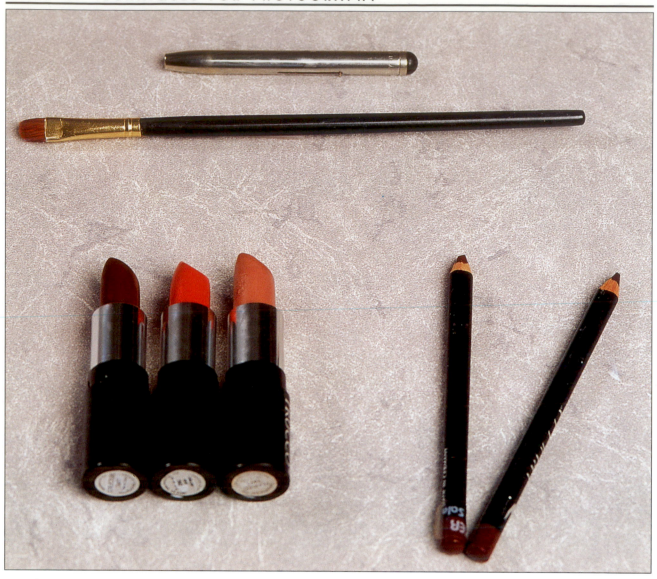

Make-up tools for the lips.

If you're not happy with any of the colors available for sale, or in your immediate make-up kit, mix something up. Lipstick and cream can be combined in a small container with a tiny spoon or spatula. Once mixed, apply the new color with a lip brush.

A note about lip colors—they often look different in the package than on the lips. They may also look different on different women. The only way to tell is on the lips being photographed. Application to the back of someone's hand will not tell the full story.

☐ Types of Lip Make-up

Everyone says lipstick when talking about coloring the lips. They really mean lip color. There are several different make-up solutions that can be applied to the lips. Most make-up kits and artists take advantage of them all.

• Lipstick

The most common way to apply color to lips is with a tube of lipstick. It's the easiest, too, although you may not think so after coloring a few hundred sets of lips by other methods. Because the names of lipsticks can often be much different than the color you expect, mark the little end label with a small swipe of the color immediately upon opening the first time. This way you will always know the exact color inside.

The most common way to apply lip color is with lipstick. It is also one of the easiest.

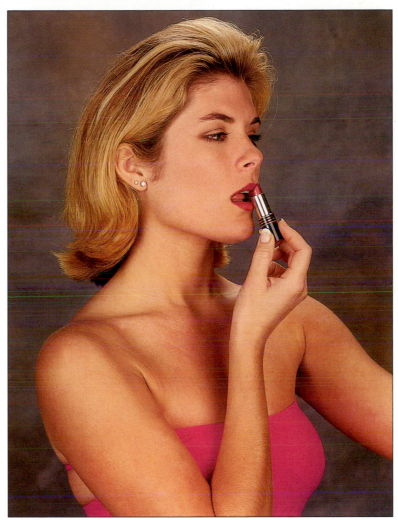

• Lip Cream

Lip cream is pretty much the same as a tube, but in a small pot or compact case. It's a little softer and needs an application brush. Mark the top with a little dab of the cream, unless it's in a see-through top. Lip creams are available in several finishes, including a shiny, sheer see-through, and matte or dull.

• Lip Stain

This product is just what the name implies, a long-lasting lip color. A stain doesn't run or come off easily. This is

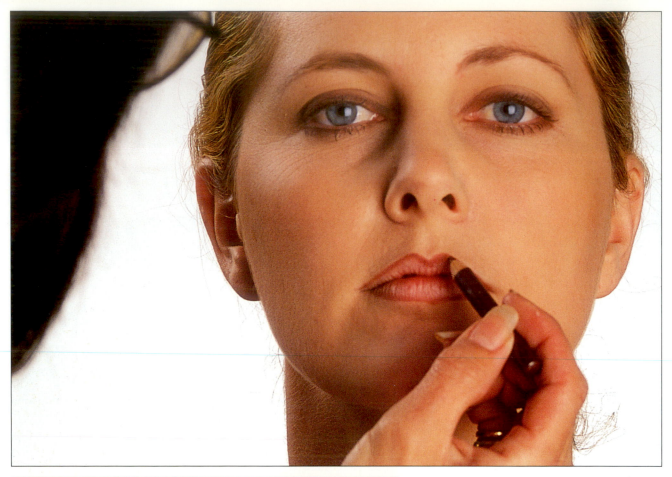

Step One (above): Use a lip pencil to out-line the lips.

Step Two (left): Using a brush (or other method of application) fill in with a lip color close to the pencil color.

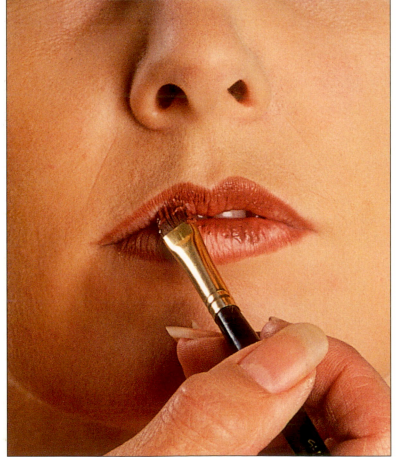

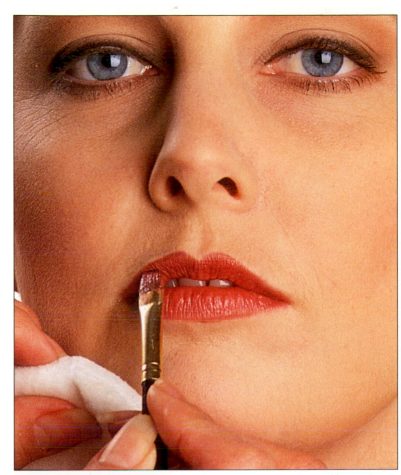

(Right) For an evening look, a darker lip color may be applied.

Step Three (Below): Blot the lips and re-apply for longer lasting color.

not a choice for models working several shoots in a short period of time. It is not available in a gloss finish.

• **Lip Pencil**

A lip pencil is a hard pencil of lip color, much like an eyebrow pencil. Most of the time, pencils are used to outline the lips, rather than apply color directly to them.

• **Lip Gloss**

Lip gloss is a shiny cream that is available in clear, transparent or colored versions. It is primarily used over lip coloring to enhance the shine. It can also be used instead of lipstick, for a shiny natural look.

• **Lip Matte**

Like lip gloss, lip matte is clear and transparent. It is used to cover the lip color with a dull see-through finish.

☐ Application

Apply a light base of sheer foundation or powder before adding any lip color. Most make-up artists prefer doing color applications with a lip brush. This allows a more accurate and complete application.

For all photographs where the lips are not the point of emphasis, start with a lip pencil that is exactly the same color

Use a tissue to gently remove lipstick after the shoot.

"... ask the model to open her lips and blot down on the tissue."

as the lip color. Use it to outline the lips. Next, use a brush to add lip color within the pencil lines. Start with a light application and step back to see if more is needed. Add more only if necessary.

If the eyes are to be emphasized, don't go too heavy with the lip color, or use the lip pencil outline as the only lip make-up.

If the lips are to be the primary subject in the photograph, you should outline them with a lip pencil first. The pencil color should be slightly darker or lighter than the lip color. A tiny line is better than a wide one, unless you want an extremely strong emphasis on the lips.

The lip color will last longer if the model blots with a sheer tissue and a second coating of color is applied. While you're blotting, ask the model to open her lips and blot down on the tissue. Tug slightly as the lips are pressed down. This will remove excess lipstick, which can end up on the teeth.

In all cases, a bright or glossy lip color can be toned down with the application of a little lip matte or light dusting of powder.

In contrast, any soft or matte lip color can be enhanced with a dot of gloss placed in the lip center and softly brushed outward toward the edges. Adding lip gloss enhances the shine and beauty of the lips, but it also tends to tone the color down a little. This works best when a bright color is good, but a little too bright.

☐ Removal

Remove lipstick first when cleaning up after a shoot, and at the end of every day. It's the messiest of make-ups and can get into everything when you wash.

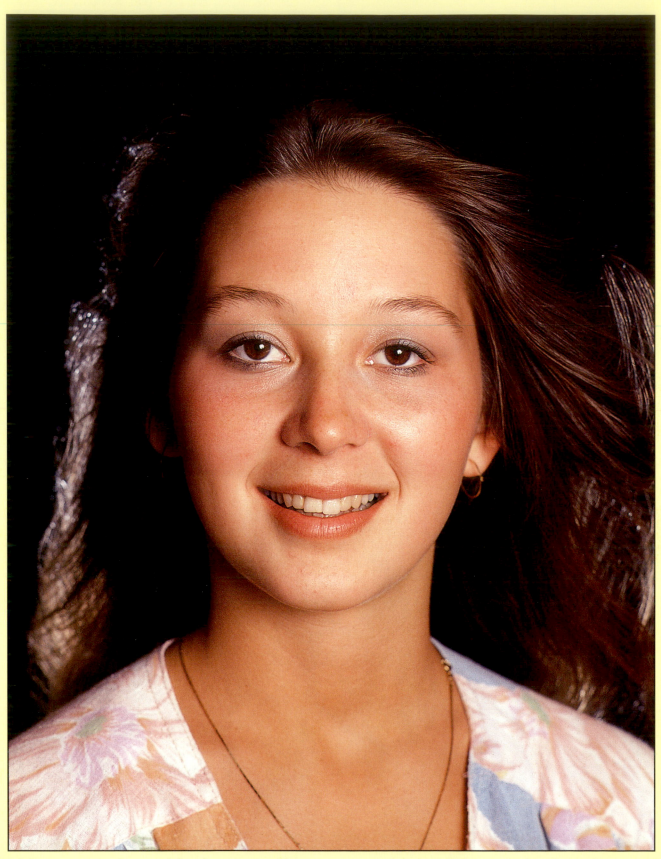

Make-up can set the mood for the portrait. Here, a young model wears light, natural make-up for a more fresh and casual look.

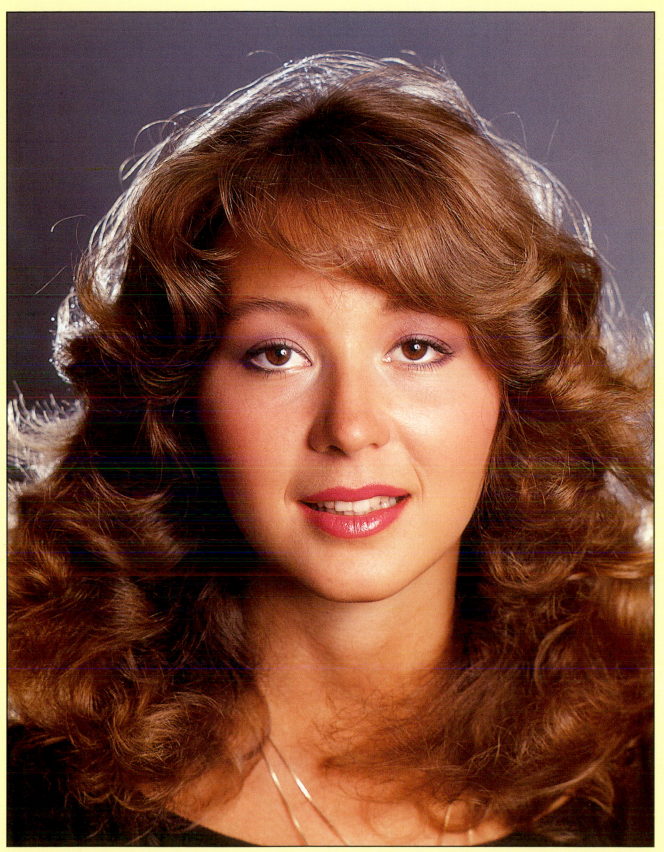

In this portrait of the same model, deeper tones on the eyes and lips and additional contouring of the face yield a more sophisticated evening look.

8

MAKE-UP AND THE EYES

When the face can be clearly seen by the camera, the eyes are the single most important part of a photograph. They will determine the mood of the final image. Photographers and models must pay more attention to the eyes than any other part of the make-up process. Do not allow any other part of the face to compete with or overwhelm the eyes. The only exception to this rule occurs in instances where the lips are intentionally the primary subject of a photo set-up. We've put the eyes last under make-up application only because they are the most complicated part of the face to make-up. We suggest starting the eye make-up application immediately after the foundation. This will make it easy to remove or cover any little drops of mascara that fall on the face during the process.

☐ Eyebrows

Trimming and Tweezing. Grooming is the primary method of styling eyebrows for photography. This includes minor trimming or tweezing of stray hairs. If a model has extensive brows that need tweezing, this should be done long before coming to a photo shoot, and probably by a professional. Tweezing the eyebrows immediately before a shoot will result in redness where the unwanted hair was removed. This must be covered with concealer.

Models with very thick eyebrows should not try to remove everything but a tiny line. Even if this is the current rage, it won't last, and the maintenance will never end. On the other hand, if a model's brows hang down in front of his or her eyes, they do need to be thinned or trimmed. Go easy

"... the eyes are the single most important part of a photograph..."

58

when completely removing eyebrow hair, because it takes a while to grow back and cover mistakes. Models who need (or want) major changes in their eyebrows should utilize the services of a professional make-up or styling artist.

Whenever grooming the eyebrows, try to maintain or follow the natural arch of the eyebrow. Changing or removing this natural growth will alter the model's face and overall look. Try covering unwanted arches and hair with a little white make-up before removing it completely. This will give you an idea what the final look will be. Go slow when removing unwanted hair. First off, it's easy to make mistakes. Second, it will hurt.

Styling. Start by brushing the brows with a small soft brush, or eyebrow comb. If they won't stay in place, add a small bit of hairspray to the brush and do it again. This

Step One: Style the brows with a small brush or eyebrow comb.

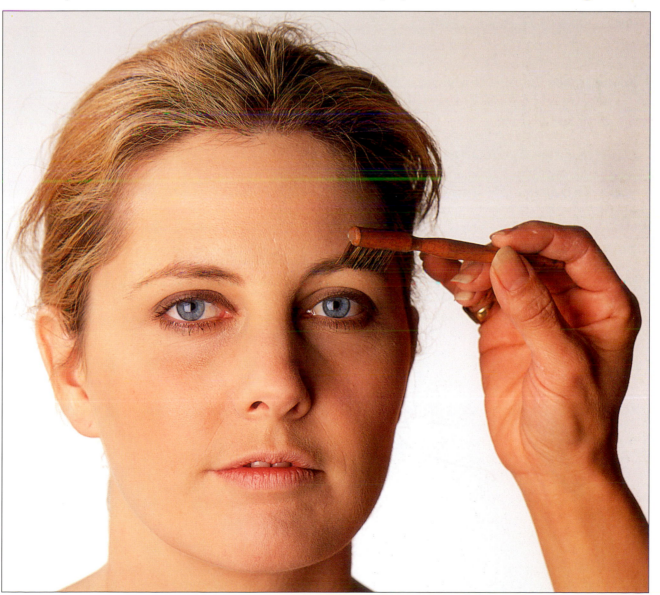

should keep them in place for most of the photo shooting day.

To fill any gaps or strengthen thin eyebrows, use an eyebrow pencil that's slightly lighter in color then the brows. The same effect can also be accomplished using a make-up brush and eyeshadow. As with the pencil, use a slightly lighter shade than the brow.

Bleaching. Leave bleaching of the eyebrows to the professional make-up artists. This is a drastic measure to take just before a photo shoot. Also, it takes a long time to grow back. If you want a much lighter eyebrow look, use powder. Iif that isn't enough, use white make-up. If a model has brows that are too light, simply use the pencil or a little eye shadow to darken them.

☐ Foundation

A soft cream foundation around the eyes will make them ready for make-up or color. You can also reduce circles under the eyes with a tiny bit of concealer, but go easy. Using too much will make the model look like a raccoon. After applying concealer, add a touch of foundation, blend, and set this base with powder.

☐ Curling the Eyelashes

If the eyelashes are to be curled, do so before adding any make-up or mascara.

> "Leave bleaching of the eyebrows to the professional make-up artists."

Step Two: Curl the eyelashes (if desired).

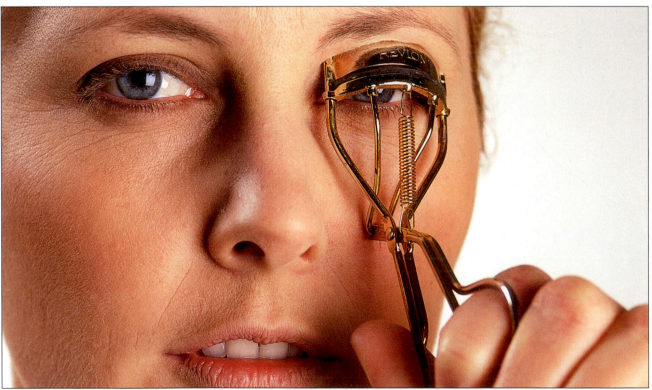

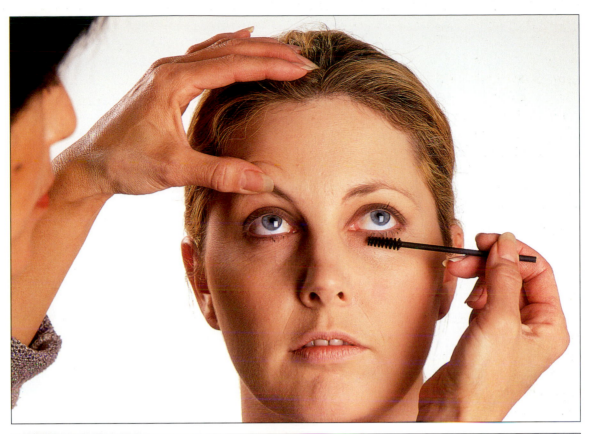

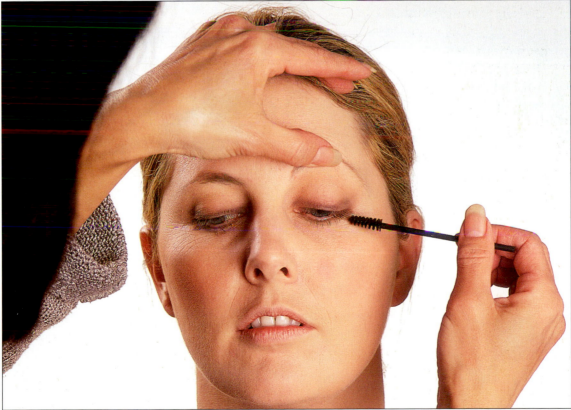

Step Three: Apply a light coating of mascara to the upper and lower lashes. Let it dry, then apply a second coat.

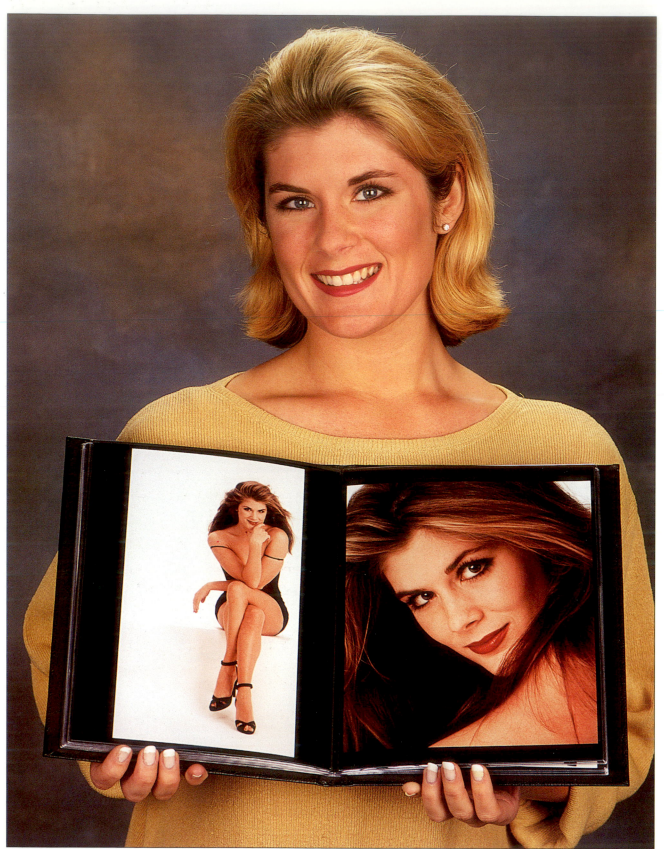

It's easy to see how different make-up and hairstyles can drastically change the look of any model.

☐ Mascara

For beginners, start making-up the eyes with the mascara. This will make it easy to clean up the eyelids if small particles should drop during the application. Professional make-up artists generally do the mascara last, knowing exactly how to prevent droplets of the make-up from falling onto the rest of the face.

To apply mascara, have the model look straight ahead. Use a light brush and a color of mascara that matches or is slightly darker than the eyelash, to add a little depth to the eyes. A slightly lighter shade will lessen the depth of deeper eyes. These looks can be enhanced with eye shadow.

Start with a light coating, let it dry and then build up with a second coat of mascara. Flick the brush against the mascara holder to eliminate any little drops. Be careful not to let any drops fall to the model's face. Do the top lash first.

If the eyes need more depth than the mascara gives them, use a fine point matching color pencil to apply a very thin line to the lash line of the eyelid. Eye shadow can also enhance the depth of eyes.

☐ Eye Shadow

Eye shadow should enhance the model's eye color and eyes. It can add a little depth, or it can make them look like a raccoon. For this reason start with a little, step back and take a good look. Add more as necessary.

Eye shadow comes in five forms:

- **Powder**

 By far the most popular is the powder eye shadow. It's easy to apply light coats with a soft brush, adding and blending where necessary.
- **Cream Powder**

 This is a thicker soft shadow that requires a good professional brush to apply. Along with the standard powder, it's also favored by professionals.
- **Cream**

 These are the pots of color that must be applied with a sponge or finger. They require some experience, or you will leave blotchy marks.
- **The Pencil**

 A thicker point shadow applicator, which is easy to control. A back up for the powders.
- **Eye Lacquer**

 A very thick and paintlike substance that gives a dramatic metallic effect. Popular in ghost-white face photos.

"Eye shadow should enhance the model's eye color and eyes."

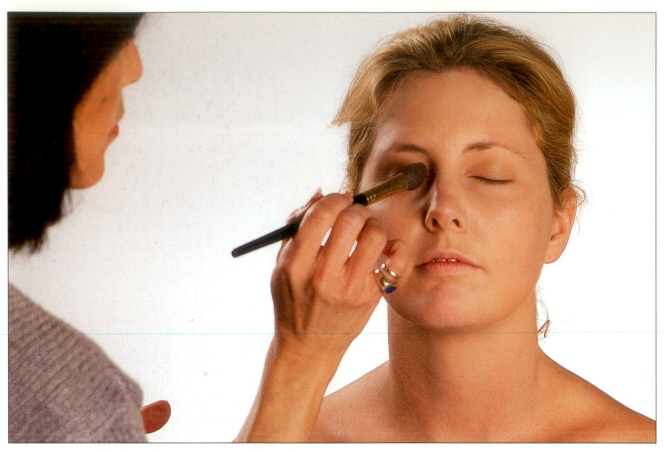

Step Four: Apply eyeshadow to the upper (above) and lower (below) eyelids.

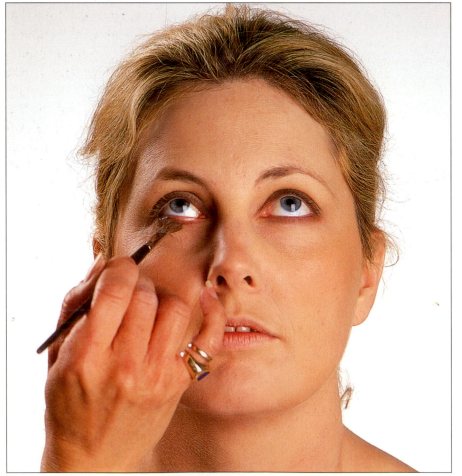

Colors. We know there are almost as many eye shadow colors out there as there are lipstick colors. Forget about keeping a wide assortment of everything that's available. Don't experiment with unusual bright colors during an important photo shoot, unless that is the subject of your shoot. Instead, when you have some extra time, experiment with a model looking for some interesting head sheet shots.

Stick with softer natural colors that let the eyes do the talking. The soft and lighter browns and grays are the best place to start. Blondes look best with neutral colors that are soft and light; deeper tones will make their hair color seem darker. Redheads seem to look better with a soft red-brown color. Start light with the color and build into the look you desire.

Bright eye shadow colors, and very dark ones, are available for those who want special looks. Sometimes you may want to match a wardrobe color, or other products, and have the eyes really stand out in the process. With intense or deep colors, try a little first and then add as you go until the desired look is achieved. There really isn't much blending possible with the solid and brighter colors.

Do not use pure white, or solid black, for that matter, around the eyes unless a special look is desired.

Application. Avoid too much of any color and too-wide coverage. Use a good soft brush, working from the lashline upward to the eye's natural crease. Blend as you go up and outward. Try to stick with the eye's natural shape when blending.

Use a little darker or warmer shade of shadow above the eye crease, up toward but not touching the brow. This will add depth to the eyes in a photograph. In social situations it's best to go with a lighter color. Brush and blend this in softly. Don't extend this beyond the eye's natural curve.

Use a tiny bit of darker shadow, applied with a pencil, just above the lashline to darken the area slightly. Blend outward, with the lightest part in the center.

Models with narrow, closely-set eyes should use a slightly darker color, blending upward and outward to widen the look. Step back and make sure the blending brings the eyes out. Avoid putting any shadow near the inner area of the eye.

Apply a tiny bit of soft light brown below the eye brow and blend in well as a highlighter. A little goes a long way in this area.

Always start with the lighter colors and move to the darker colors, blending as you go. Think within one color range, working from lighter to darker to lighter. There are very few

> "Avoid too much of any color and too-wide coverage."

times when several different colors are needed for a single set of eyes.

Set the eyeshadow very softly with powder, which will help maintain the look much longer under harsh lighting or weather conditions.

For an evening look, eye make-up may be intensified.

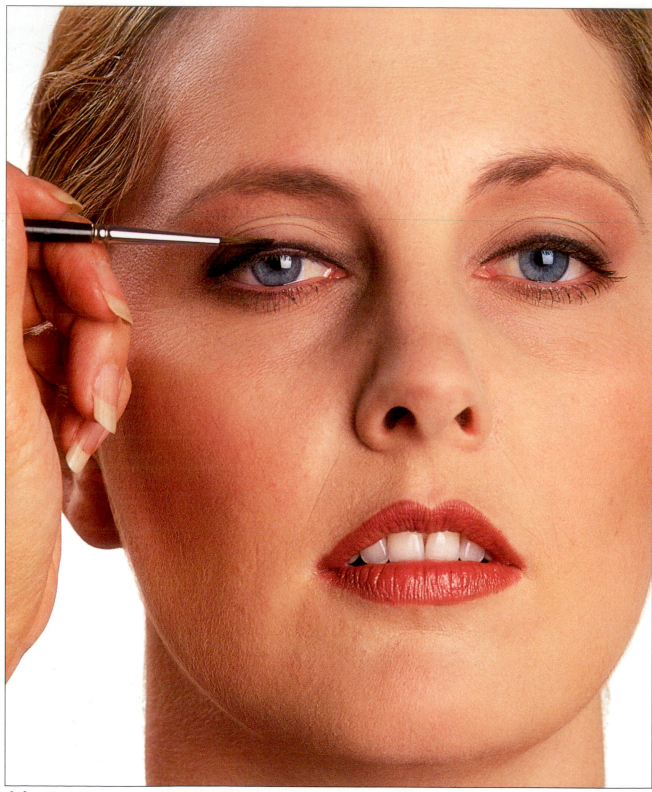

☐ Eye Pencil

Colors. Start with a lighter color than you think is necessary. This can easily be darkened. Otherwise, you must remove the first line if it's too dark. Browns and soft black are best, as they don't leave such a hard line. If you want a hard line, use a solid black liquid eye liner.

Colors other than browns and soft blacks are for special applications, not general photo shoots. Use the eye shadow if you want to add a little color around the eyes. The object is to enhance the color of the eyes.

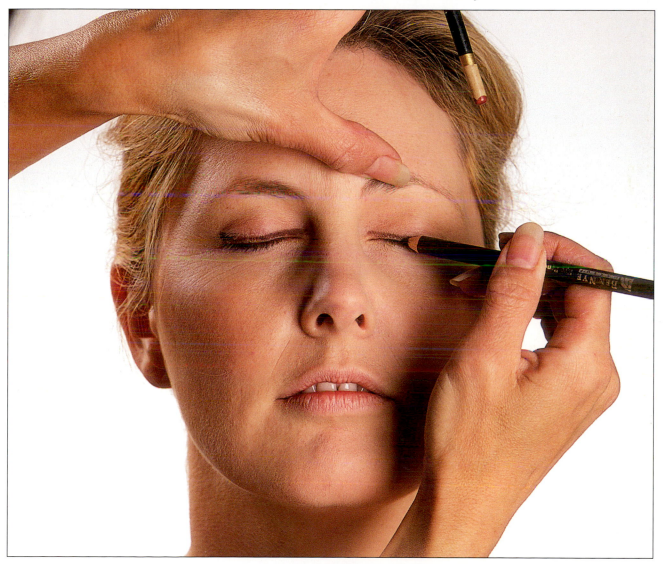

Step Five: Apply eyeliner to the upper lid, as close as possible to the lashline.

Application. Apply eyeliner after eyeshadow, never before. When outlining the eye, start thin and use a fine but somewhat dull pointed pencil. Too much liner around the top and bottom will make the eyes appear smaller, so go easy until the desired look is achieved. We suggest only doing the top of the eye, which gives a more natural look.

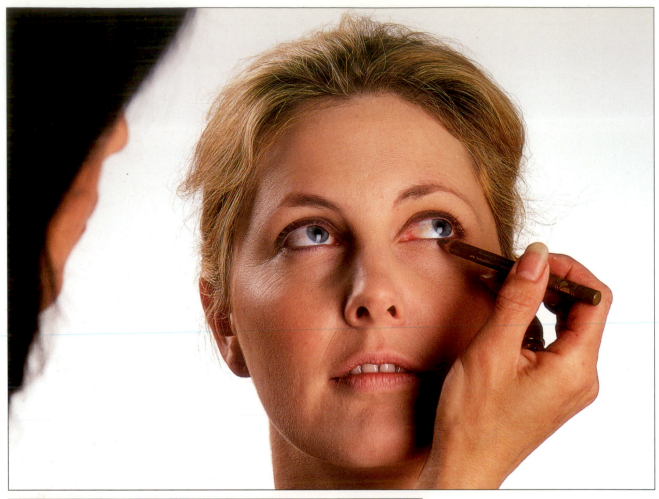

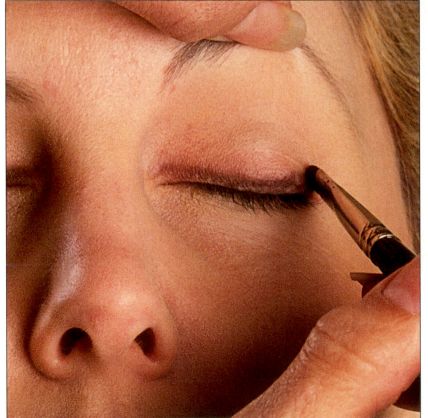

Step Six (above): If desired, apply eyeliner to the lower lid, as close as possible to the lash line.

Step Seven: Blend the pencil line on each lid using a soft brush (left) and/or a sponge (opposite).

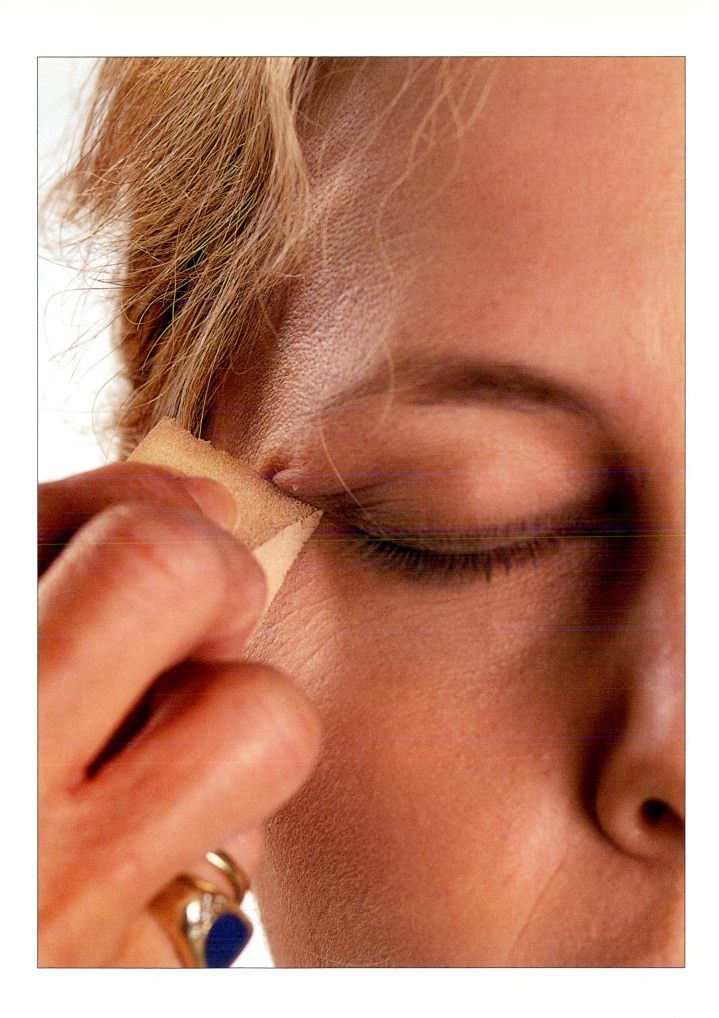

Apply the eyeliner as close to the lashline as possible. A soft line is best and less noticeable. Don't drag the pencil across the eyelid, which is sensitive and thin. Blend harder lines with a soft sponge or brush.

A brush and liquid eyeliner, and thicker line, will give your model the alluring or vampish look, which may be desired. This takes a very steady hand to apply.

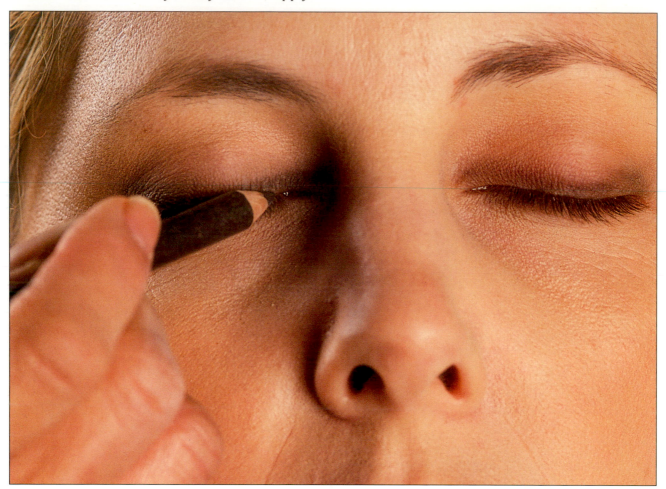

Please do not add little dark ends from the eye outward. This is an amateur make-up look, and will stand out as such. Some women like this look in social situations, if they have narrow eyes, but it doesn't photograph well.

When you have finished the application, set the eyeliner softly with powder.

Applying eyeliner with a pencil is generally easier than using a liquid eyeliner.

☐ False Lashes

False eyelashes are another specialty prop item. They are difficult to apply and should be done by an experienced make-up artist. Otherwise they will look exaggerated in a photograph, making the eyes look funny at best. They almost always look false and should be used when an obvious special look is desired.

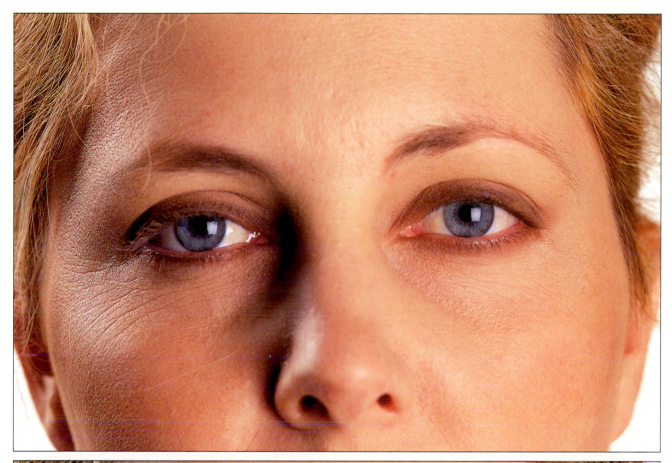

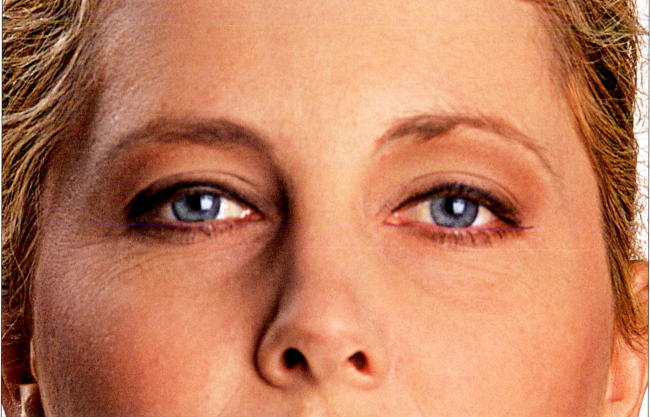

Natural (top) vs. evening (bottom) eye make-up.

☐ Removal

Eye make-up should be carefully removed using a cotton pad. The skin in this area is very delicate, so be extremely gentle. Many products are available to help remove make-up. Follow the directions on the product and use caution when applying any product to the eye area.

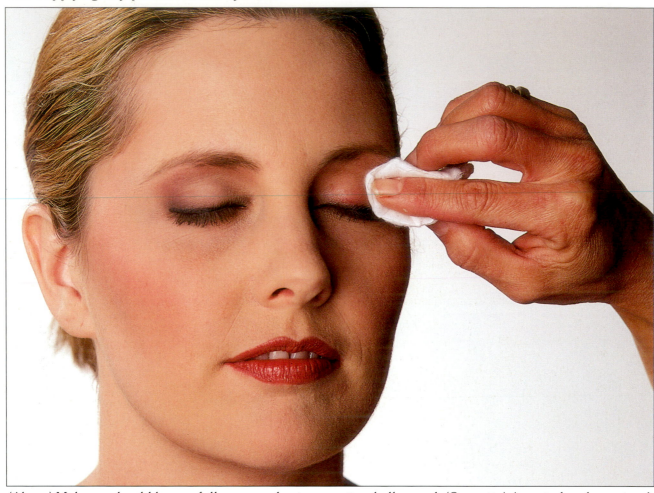

(Above) Make-up should be carefully removed using a cotton ball or pad. (Opposite) Assorted make-up products for the eyes.

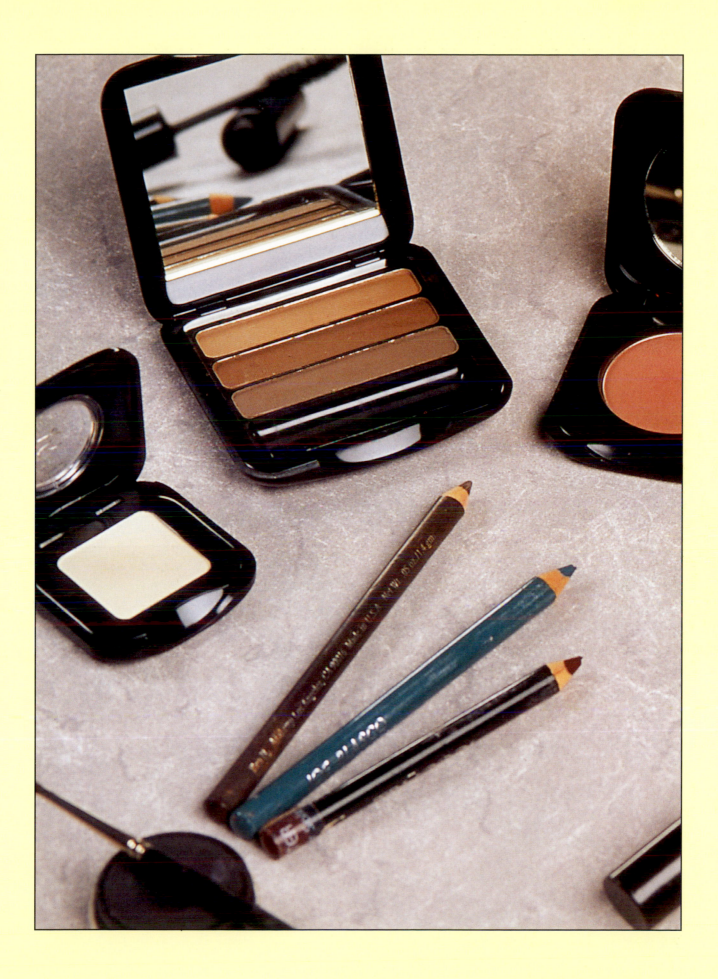

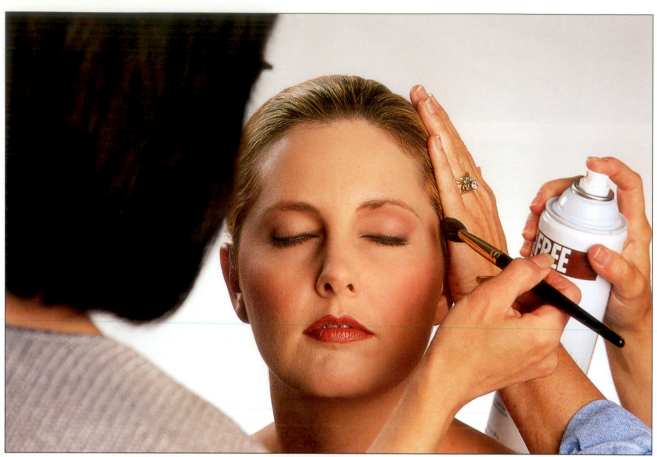

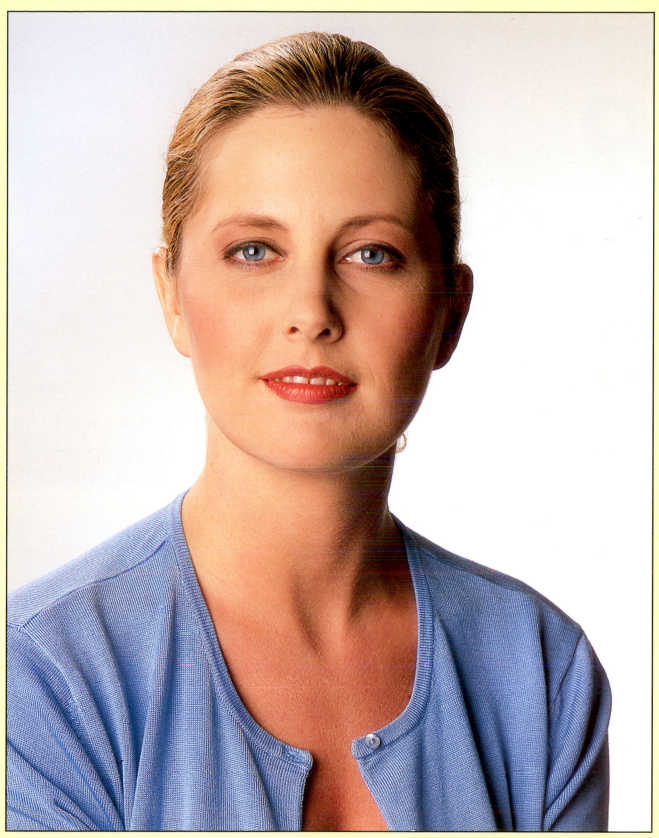

When the full face has been made-up, evaluate the results and make any last-minute changes that are need-ed (opposite, top and bottom). The result should be a flawless, blended look. Here, the model's make-up is a bit more intense, giving her an evening look, as opposed to a more subdued natural look.

9

MAKE-UP AND THE BODY

The body is just like the face. The skin isn't as sensitive, but it's just as important if you're a swimsuit, lingerie, glamour, shoe or fashion model.

Clean and clear skin is just as important to a model's body as it is to the face. Diet is the easiest way to develop clear and healthy body skin. Simply eating fresh fruits and vegetables is the first step. Drink lots of pure water, avoiding all carbonated, sugar-added drinks and fake fruit juice beverages. Avoid eating candy and sweets. Obviously, you should avoid anything that results in a rash or causes the skin to become flushed.

> "Diet is the easiest way to develop clear and healthy body skin."

☐ Keep it Clean

Cleanliness is the easiest way to keep your skin healthy. Body make-up and paint, and dirt from air pollution, will clog the pores. It is important to get into a daily routine of cleansing your skin in a shower or bath. Use a good body shampoo, soap or scrub if you shower, bath crystals, soap or oil in the tub.

☐ Deep Cleansing

The body skin needs to be deeply and completely cleaned every two weeks. Get into a twice-monthly routine of deep cleansing and exfoliation of your body skin. This might be easier to do with a membership to a professional spa, although there are some good home kits available. If you're not sure which products to choose, ask a professional make-up artist for suggestions on which products are best.

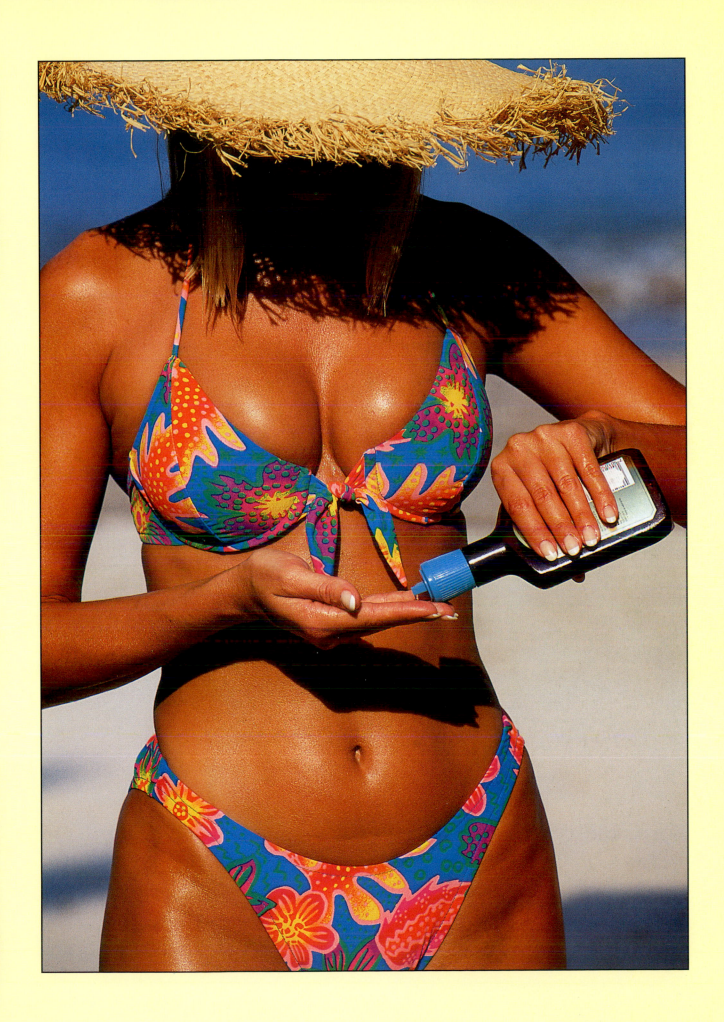

◻ Tanning

The sun is tough on skin—no matter where the skin is located. Stay out of the sun, or use a very strong sun block. If you need a tan for photo shoots, try the new fake tan products. Some of them are very good. If you must have a real tan, use a tanning salon that utilizes the body-safe kind of light system. If you do this, get an all-over tan, which will eliminate tan lines showing with all fashions.

For all those young models who must have a real suntan, or just want to play in the sun, start with very short exposures to the sun, using a good sunscreen. Try to tan in a private place so you can get overall coverage.

As you start getting color, move to a good suntan lotion that is oil based. The oils seem best for deeper tanning. Try one of the mixtures that is part fake tan and part real tan. The oils offer much less protection from the sun's damaging rays, so don't fall asleep and get a bad burn. Again, remember the sun will eventually hurt your body if

"The sun will eventually hurt your body if you spend too much time in it..."

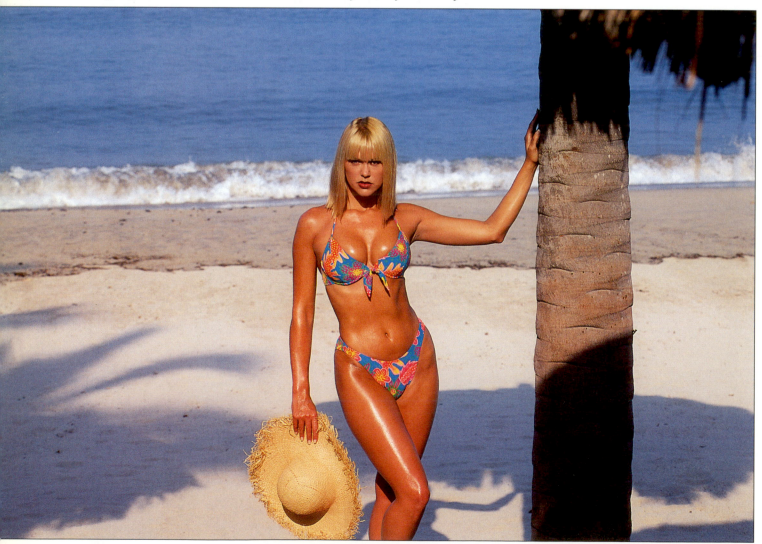

you spend too much time in it, with or without protection. This can result in premature wrinkles, skin discoloration and even skin cancer.

□ Rashes

If you are prone to skin rashes, there are a wide variety of hypoallergenic body make-up products and special medical formulas available. If you experience rashes and reactions to soaps, make-up or foods on a regular basis, seek the advice and treatment of a dermatologist.

A good cleansing program may help eliminate or reduce some of the skin problems just mentioned. Talking with a dermatologist will also help.

Tight and constantly rubbing clothing can cause rashes and skin burns. So can clothing like leather, rubber and plastic. Selecting looser clothes with natural fibers (like cotton) can be helpful if this occurs.

Heavy body make-up, or paint, will also prevent the body from breathing and may cause rashes or more serious reactions. If you use paint products on a model for a photo shoot, make sure they are hypoallergenic and made especially for body painting. Do not use standard artist's paints, and do not cover the entire body with heavy make-up or paint. (See the body make-up section to learn how this should be done properly.)

Dirt and heavy suntan products can also cause rash problems. Always cleanse the skin after exposure to harsh elements, use of suntan products and body make-up.

□ Tattoos, Scars and Blemishes

Scars, burns, birthmarks and tattoos can often be covered with a layer or two of the same type of concealer used on faces.

If you have one of these marks, or unwanted hair, and modeling or acting is your career, you may want to make a more permanent change. This means you need to talk with a cosmetic or plastic surgeon. These sciences have advanced to the point where the doctors perform what seem to be modern miracles.

When it comes to any medical procedure, don't take any unnecessary risks. Ask around for recommendations, and always go with the most experienced doctor. It's also a good idea to talk with your family doctor first.

□ Body Moisturizers

Apply a soft skin moisturizer all over your body after showering, or taking a bath. There are a number of nice

"Dirt and heavy suntan products can also cause rash problems."

For shoots around water, using waterproof make-up is a must.

smelling and feeling body lotion products that help keep the body skin healthy. Along with regular exercise, these treatments will help keep the skin clean, firm and soft.

☐ Hands

Use the same care for the hands as you use for the rest of the body. Remember they probably get more exposure to the elements and tough daily use than any other part of the body. Apply a good moisturizing lotion after every washing. Use one with good sun blocking ingredients, so your hands will match your face and body color. Keep your fingernails clean and neat, too.

☐ Body Makeup

The body is much the same as the face when it comes to the selection and application of make-up for photography.

Concealer should be used on the body to conceal scars, burns, birthmarks and tatoos.

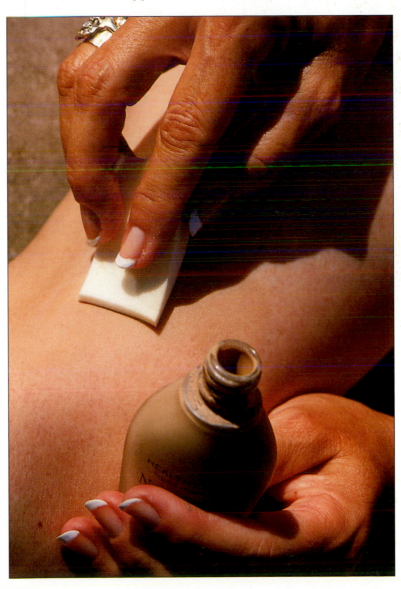

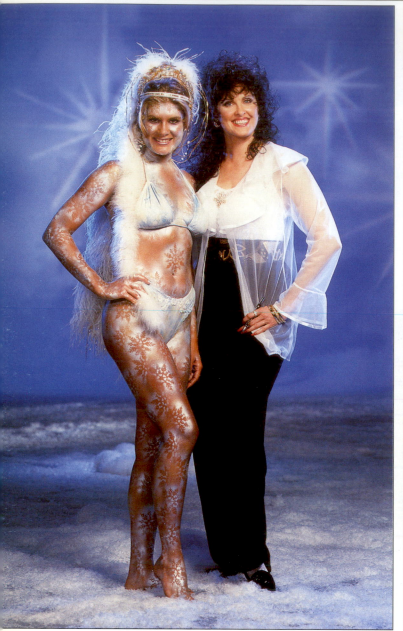

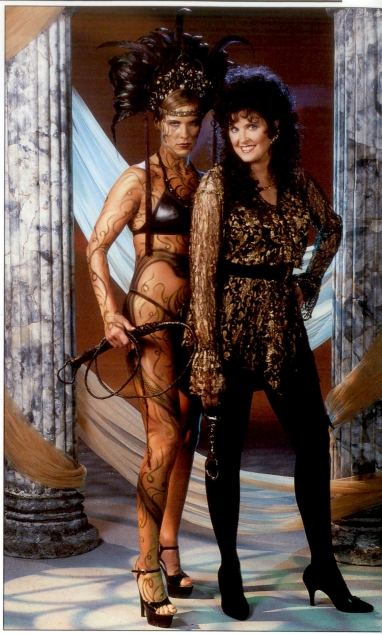

Because the body's skin is often tougher and less sensitive, application of make-up on the body is generally easier than on the face.

There's little reason to apply foundation to the body, unless it's for an unusual situation such as complete painting or covering. In such cases it's useful to lay down such a base to protect the skin from the paint. (WARNING: If you are painting or making-up an entire body, leave a three or four inch square in the lower center back just above the tailbone completely uncovered by any make-up or paint. This is necessary so the skin can breathe properly.)

Concealer should be used to cover scars, burns, birthmarks and tattoos. As with the face, try to match the skin

Airbrush artist Linda Love uses specially formulated paint made specially for use on the body. She creates very different looks using the same techniques. Photo courtesy of Bruce Carroll Photography.

82

color as closely as possible. Try to find a product that protects from the sun and is waterproof, which is especially important for swimsuit models. Lingerie and glamour models working inside should set all body make-up with a light dusting of powder.

☐ Airbrush Makeup

Some very interesting body make-up can be applied with an airbrush. Bodies are often painted on by fine artists for glamour shoots and film projects. First attempts at this type of application should be created under the supervision of an experienced artist. The airbrushes are very powerful and can cause skin irritation and damage.

Always use airbrush paint that is specifically designed for body painting. Using other types of art paints may cause skin rashes and irritation.

☐ Unwanted Body Hair

Body hair does not look good in a photograph. There's little a model can do to stop the growth of body or facial hair, which are more prevalent with the use of birth control pills and age.

There are a few things a model can do to eliminate body hair. The easiest, for fair skinned people, is to use a good bleaching product. This won't work if you have dark skin or dark hair. There are a few good chemical cream hair removers that seem to dissolve unwanted hair for a few days. Professional waxing does a great job, too, but can cause irritation to the skin for a day or so.

Body hair can be eliminated by professional electrolysis. Talk with a dermatologist and get her recommendation. It will be costly, but for professional models it may be worth the investment.

The best way to eliminate body hair is by shaving it off. Using a safety razor in the shower or bath provides the cleanest and longest-lasting results. If this causes a rash or irritation, use one of the lady electric shavers—but not in the shower, unless the model is specifically made for such use. Professional models often carry a battery powered electric lady shaver on shoots for last minute touch-ups.

☐ Foot Care

If your body is going to show in a photograph, then your feet may also show. They need the same type of care as your hands and fingernails. Even more.

Keep your feet clean and dry. Use a good foot powder, spray or apply a light ointment to eliminate athlete's foot.

"Body hair can be eliminated by professional electrolysis."

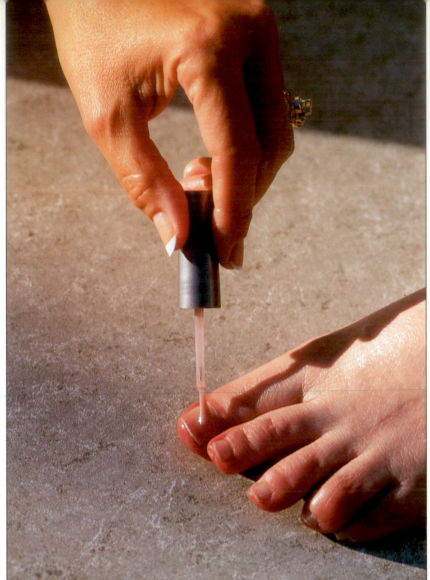

(Left) Keep the toenails clean and clipped, and painted with pale or neutral polish.

(Below) Cracks and flaky skin can be corrected by using a good moisturizing cream.

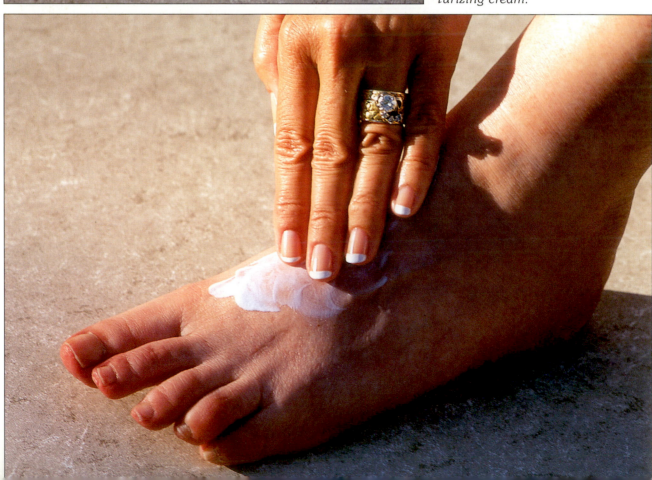

This fungus isn't just found on athletes. Anyone who wears hot, dry shoes, especially leather ones, can get it. Heavy socks make your feet sweat, which also attracts fungus.

Care for your toenails just like the fingernails. See a professional for a pedicure on a regular basis. See a foot doctor if your feet look like something from the swamp.

Cracks around the heels, and flaky skin on the body, are a sign of dryness and may be improved with a little bag balm. If you haven't heard of this great medicated salve, ask the druggist.

Keep your toenails neatly clipped, just like your fingernails, and painted with neutral or clear polish.

□ Fingernails

Good fingernails look great in photographs. Bad ones stand out like a sore thumb. Dirty, broken, poorly colored, chewed and ragged nails won't cut it in a photo shoot. This is true even if the nails aren't part of the product.

Models should make regular visits to a professional manicurist. Not only can they keep your nails looking good, they can repair broken ones and teach models lots of useful tricks for their own care and repair. The same goes for toenails when models anticipate doing swimsuit, lingerie or glamour shoots.

Even when nails aren't part of the product, broken, chewed or ragged nails stand out like a sore thumb.

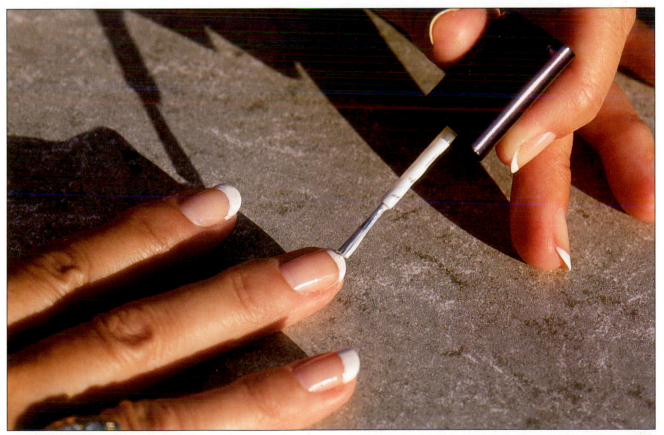

Nails should always be kept clean. Use a soft brush in the shower or bath after washing hair. This is when the under-nail is softest and easiest to clean. Keep nails filed at all times, to prevent breakage and snags on wardrobe. Keep nails painted with a strong clear coat. Colored nail polish should always be applied over a dry clear coat.

Broken nails should be carefully repaired and replaced by a professional.

Color selection for nails should be done at the same time make-up is applied. Most of the time it should match the lip color.

Women with nice long fingers and fingernails look good with bright nail colors. Darker color nails stand out and often make fingers look stubby when they are not.

☐ Teeth

A bright white smile is the single best attribute a model's face can have. No matter what the rest of a model's face looks like, a bright smile will make her look better. This is true, even if a smile isn't required for a specific photo.

Keeping teeth white requires a good dental plan. Brush after every meal.

"Sometimes these stains can be removed to a brighter white."

Keeping teeth white requires a good dental plan. Brush after every meal. Some of the whitening toothpaste seems to keep teeth white. Talk with a good dentist, and fellow models, to find out which brands work best.

Teeth start out fairly white, however, drinking colas, coffee, tea, red wines, and eating lots of sugar will cause them to stain a darker color. Sometimes these stains can be removed to a brighter white. Don't use a cheap drugstore bleach for this process. Talk with a dentist and make sure your teeth will take the process, and use the process they offer.

The other options for maintaining bright white teeth include having them painted with a white bond or having them capped. This is a serious dental procedure, and should be discussed with a professional.

10
PROPS AND ENHANCEMENTS

☐ Props

There are dozens of props that can add to the face and make-up application. All of these things can enhance or distract, depending on how they are used. While many of these items are for specialty shoots, occasionally they will enhance a normal make-up application.

Jewelry and glasses are the most common face props. More exotic looks can be achieved with feathers, face jewels and facial airbrush painting. We know a great body paint artist who paints things like flames, voodoo marks and peacock feathers on her models' cheeks.

If the object is to distract from the face, Venetian half-masks make great photography props. Wigs and hats can also be used to enhance the face.

☐ Make-up Enhancements

The number one make-up enhancement is false eyelashes. Exact matches to normal eyelashes can add to blonde, missing or very fine natural lashes. Larger lashes will help draw attention to the eyes, or emphasize a needed look. Going too big is generally so obvious that lashes will look fake in pictures. In fact, only the very best false eyelashes will look real. Keep in mind that the camera, and studio lighting, will magnify false lashes.

A creative beauty mark on the face or body will often enhance a photograph. A small beauty mark can also cover up a blemish or pimple. Smaller is better in any case.

A favorite for younger women is a light sprinkle of glitter powder. They come in all sorts of colors, silver and gold.

They look great along the neck and bust line, so long as there aren't so many it looks like an undiscovered gold mine. It works in the hair and on wardrobe too. The same products are available in eyeshadow, for lips, and in fingernail polish. Some entertainers have used smaller sequins and tiny stars in the same manner as glitter. Just make sure they don't overpower hair or clash with the wardrobe.

☐ Contact Lenses

Recently, we've seen professional models and actresses who utilize a wide variety of contact lenses. This allows them to match any fashion or mood with an eye color. Soft plastic and replaceable lenses are the best and easiest to master for those who don't normally wear contact lenses.

Sunglasses are a common face prop which can enhance a photograph.

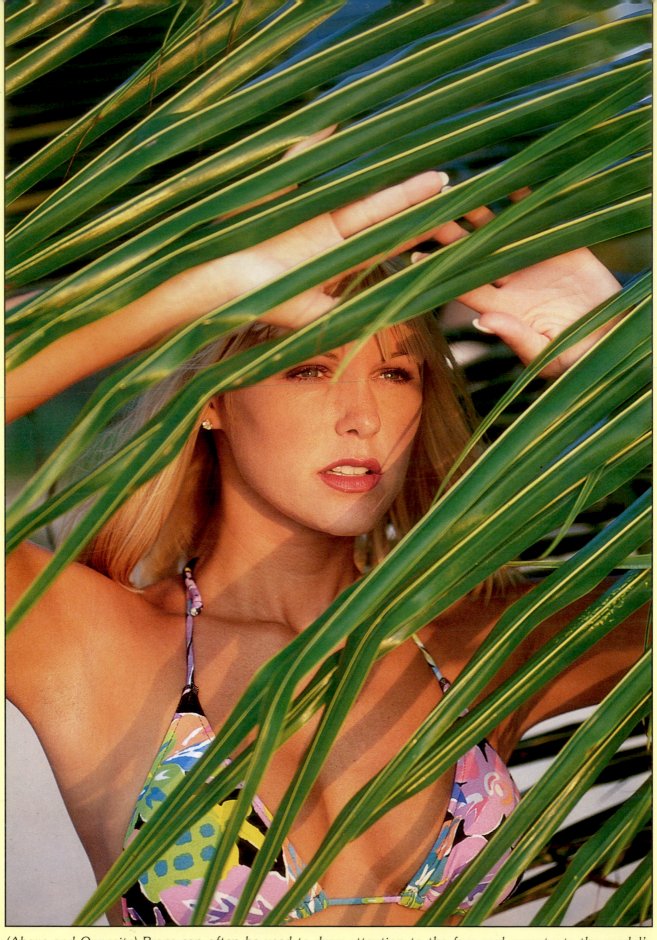

(Above and Opposite) Props can often be used to draw attention to the face and accentuate the model's make-up.

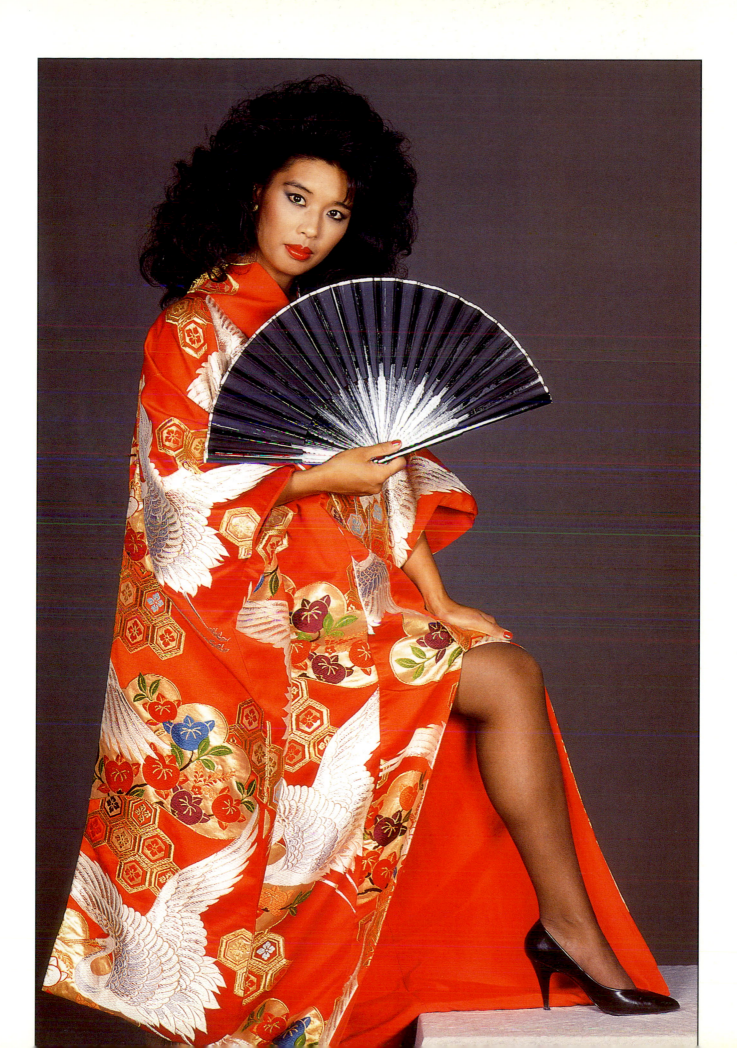

11 REFERENCES AND RESOURCES

While there are literally thousands upon thousands of places you can look for information about the world of make-up and photography, we've tried to list a few of the best. These resources are meant to be the starting place for your library.

☐ Books

Making Faces
By Kevin Aucion

If you're serious about make-up, this guy is without a doubt a true master. This is his best book on the how-to aspects of the profession. Many make-up artists have a problem sharing and teaching others their techniques, but not so with Kevin. He shows off such famous faces as Demi Moore and Nicole Kidman, while showing you step-by-step techniques of making up the perfect faces for the camera and some interesting special looks you can also create. (Published by Little, Brown and Company.)

The Art of Makeup
By Kevin Aucion

Once you're a Kevin Aucion fan, this book will be a welcome addition. Not so much a how-to book, but a series of ideas and examples on some of the great work this artist has created. The faces on which he works include Janet Jackson, Christie Brinkley, Susan Sarandon and Jessica Lange. (Published by HarperCollins.)

Cindy Crawford's Basic Face
By Cindy Crawford, Sonia Kashuk
and Kathleen Boyes

This book is a must for every model, whether or not she wants to become an expert at make-up application. It's an excellent guide to the most practical "basics" of make-up, which professional models and photographers should also know. Cindy is a master at creating the natural beauty look. It's a no nonsense book with plenty of valuable tips. (Published by Broadway Books.)

Woman's Face: Skin Care and Makeup
By Kim Johnson Gross and Jeff Stone (et al.)

One of the most complete guides to understanding and applying make-up. Many good how-to examples, more than 100 of the most asked questions answered and lots of excellent illustrations. Good information on supplies, tools and insider tricks of the trade. (Published by Alfred A Knopf.)

Ultimate Makeup & Beauty
By Mary Quant

Mary Quant has been one of the leading consultants and product innovators in the world of fashion and beauty aids for a generation. Her book is well-illustrated, with information covering the most basic of make-up into the exotic realms of glossy glamour. (Published by DK Publishing.)

Stage Makeup
By Laura Thudium

If you're looking for the right make-up applications for use in television or the theater, this is the reference book. It is written by someone that has worked a long time in the theater and knows what it takes to look good under the harsh and hot stage lights. While this is an excellent guide for the beginner, the information is aimed at the working professional. (Published by Back Stage Books.)

Sirens
By Marco Glaviano

A collection of dazzling images by one of the very best beauty photographers in the business. It's also an intimate look into the shooting side of Marco's business. Not exactly a how-to guide for photographers, but certainly an inspiration to get out and shoot the kind of subjects in which he specializes. (Published by Callaway Books/Warner Books.)

☐ Software

Cosmopolitan Virtual Makeover

Want to see what you or a model would look like with red hair, long hair, a buzz haircut, bright blue eyes, brown eyes, in glasses or almost any other combination? This exciting software allows the user to re-make any face on the computer screen. Contains lots of cosmetic tips and brand name make-up suggestions. It's fast and easy to use. Several versions and options are available. (From Mindscape Software <www.beyond.com>.)

iStyle Personal Makeover

A fun program that offers thousands of new looks and advice on hair and make-up applications. It's a quick and easy program. (From Havas Software <www.beyond.com>.)

☐ Magazines

InStyle Magazine

A huge all-around fashion magazine, that's full of the latest information and photography on make-up application and products. Their advertisers are an excellent place to search for the best and latest make-up products, as well as high quality photography and ideas. (Published by Time, Inc.,1271 Ave of the Americas, New York NY 10020, (800)274-6200.)

ELLE Magazine

The latest look in hot models, photography and fashion-related subjects. Good place for ideas on make-up and products. (Published by Hachette Filpacchi Magazines, 1633 Broadway, New York NY 10019, (212)767-5800.)

☐ Web Sites

There are thousands of make-up, photography and fashion sites available on the Internet. List just about any subject we've mentioned in your search engine and it will provide hundreds of excellent resources for information and products. It's a quick, easy and cheap way to keep up with what's happening in the world of make-up.

Joe Blasco Make-up Centers
www.joeblasco.com

This is easily the best place to learn more about make-up, related products and supplies. It's the first place you should start in the search for anything on make-up. The site also lists dozens of excellent related links.

We thank Joe for suggesting the following sites:

Larry Bones Creative Makeup Designs
www.BoneYardFX.com

Tom Savini
www.savini.com

Matthew W. Mungle
www.nu-products.com

Gil Mosko
www.gmfoam.com

Jack Pierce
www.jackpierce.com

Harry Thomas
www.geocities.com/Hollywood/Hills/5829/

Fashion and Make-up
www.fashionandmore.com/

Naimie's Film & TV Beauty Supply
www.naimies.com

Stephanie Mazzeo, Makeup Artist
www.angelfire.com/fl/make-upartist/

DinairÆ Airbrush Makeup Systems
www.dinair.com

Makeup by OMI
www.omimakeup.com

 Take a look at Omi's web site. She did most of the work in this book and is a leading artist. When you need a pro, she's the one.

GLOSSARY

Acne cream

Medicated cream used to help clear up and prevent pimples, blackheads and other skin problems.

Astringent

Cleanser used to remove dirt, oil and bacteria from the skin.

Bag balm

An intensive moisturizing cream for the skin.

Base coat

A clear product brushed onto nails before applying nail polish.

Bleaching

Chemical process used to lighten and reduce the appearance of hair (often facial hair). This process should be used only by trained cosmotologists.

Blush (powder)

A pressed (hard) powder sold in a compact and applied with a brush to add color and/or contour to a model's face. Most often applied on the cheeks, but with occasional applications elsewhere on the face. Should be applied to a dry face and blended to create a natural, seamless look.

Blush (cream)

Cream used to add color and/or contour to a model's face. Most often applied on the cheeks. Should be applied to a moist face and blended to create a natural, seamless look.

Blush brush

A large, puffy brush used to apply blush.

Bobby pins

Small plastic-coated metal pins used to keep the model's hair out of the make-up during the application process.

Body paint

Specially designed paints made for use on the skin.

Cleansing strip

A small strip with adhesive on one side which is applied to the skin wet. As it dries, dirt from the skin is trapped in the glue and can be pulled away with the strip as it is removed.

Clear coat

A clear nail polish applied under and/or over colored polishes as a base coat and/or top coat.

Combination skin

Skin that has areas that tend to be oily and others that tend to be dry.

Concealer (compact)

Product used to hide blemishes and create the appearance of an even skin tone. Comes in soft cream and powders, and is applied with a sponge or finger. This product works well under the eyes.

Concealer (stick)

Product used to hide blemishes and create the appearance of an even skin tone. Applies just like lipstick, directly on larger spots or areas. Do not use under the eyes where the skin is too thin and sensitive for dragging the applicator across.

Concealer (tube)

Product used to hide blemishes and create the appearance of an even skin tone. Softer than the creams and sometimes more oily. Can be applied with a finger or sponge.

Concealer (wand)

Product used to hide blemishes and create the appearance of an even skin tone. Best used for tiny spots, like pimples. Be sure to blend with the surrounding skin color.

Contouring

The application of make-up specifically to create the appearance of an altered facial structure (such as higher cheek bones), or to conceal problem areas (such as a double chin).

Depilatory cream

A thick cream that is applied to the skin to dissolve unwanted hairs. In advance of use, it is important to test a patch of skin for potential negative reactions. Follow the package instructions closely and work in a well-ventilated area.

Dry skin

Skin which is prone to flaking and dry spots. May need to be moisturized more than other skin types to maintain a smooth, clear appearance.

Electrolysis

Process that permanently removes unwanted hairs. Can only be done by a trained professional.

Eyebrow brush and comb

Brush with a small comb attached used for grooming the eyebrows.

Eyebrow pencil

A hard pencil of color used to deepen or accent the color of the eyebrows.

Exfoliation

Use of a scrubbing pad or cream to slough off dead cells from the surface of the skin, revealing the smoother, younger skin below.

Eye lacquer

A very thick and paintlike substance that gives a dramatic metallic effect. Popular in ghost-white face photos.

Eyelash curler

Small metal device used to press the eyelashes into a stronger curl.

Eyeliner

Make-up product used to accent the edges of the upper and lower eyelids, giving the eyes a stronger appearance.

Eyeliner brush

Small, firm brush used to apply either liquid or powder eyeliner.

Eyeliner (liquid and powder)

Type of eyeliner sold in a liquid or powder form and applied with a brush. Somewhat more difficult to apply than eyeliner pencil.

Eyeliner pencil

Firm eyeliner product sold in a pencil which is used to apply it.

Eye make-up remover

Cleanser designed to remove eye make-up, which can be

stubborn to remove due to the sensitivity of the skin in the eye area and the long-wearing design of most eye-make-up products.

Eyeshadow (powder)

By far the most popular is the powder eye shadow. It's easy to apply light coats with a soft brush, adding and blending where necessary.

Eyeshadow (cream powder)

This is a thicker soft shadow that requires a good professional brush to apply. Along with the standard powder, it's also favored by professionals.

Eyeshadow (cream)

These are the pots of color that must be applied with a sponge or finger. They require some experience, or you will leave blotchy marks.

Eyeshadow (pencil)

A thicker point shadow applicator, which is easy to control. Use as a back-up for the powders.

Eyeshadow brush

Relatively small and soft brushes used to apply eye shadow.

Facial

Cleansing regimen that deeply cleans the skin.

False eyelashes

Synthetic strips of "lashes" which can be affixed with glue to the upper eyelid to create the look of extremely long and thick eyelashes.

Foundation

A skin-colored make-up product that is normally applied to the entire face (and often neck or other exposed parts of the body) to create an even skin tone. Foundation must be blended carefully to achieve a natural look. Foundation color should closely match the model's skin.

Hair clips

Used to keep the model's hair out of the make-up application process.

Highlighter

Make-up product that is slightly lighter than the model's skin tone and is applied to accent particular features or areas of the face.

Hypoallergenic make-up

Make-up products designed specifically to minimize adverse skin reactions to their application.

Lip brush

Brush used when applying lipstick. Choose one tapered and one flat-tipped brush.

Lip cream

Much the same as lip color in a tube, but in a small pot or compact case. It's a little softer and needs an application brush. Available in several finishes, including a shiny, sheer see-through, and matte or dull.

Lip gloss

Lip gloss is a shiny cream that is available in clear, transparent or colored versions. It is primarily used over lip coloring to enhance the shine. It can also be used instead of lipstick, for a shiny, natural look.

Lip matte

Like lip gloss, lip matte is clear and transparent. It is used to cover the lip color with a dull see-through finish.

Lip pencil

A lip pencil is a hard pencil of lip color, much like an eyebrow pencil. Most of the time, pencils are used to outline the lips, rather than apply color directly on the lips.

Lip stain

This product is a long-lasting lip color that doesn't run or come off easily. This is not a choice for models working several shoots in a short period of time. It is not available in a gloss finish.

Lipstick

Lip color that comes packaged in tubes. This is the most common way to apply color to lips, and the easiest too (especially for beginners).

Lipliner

Another name for a lip pencil used to outline the lips, rather than apply color directly on the lips.

Make-up remover

Product used to remove foundation, powder and other make-up products from the skin. Some can be wiped from the skin with a tissue, others require rinsing with water. Follow the directions provided with whatever product you choose.

Manicure

Regular cleaning, trimming, filing and polishing of the fingernails (and surrounding area) to maintain an appealing appearance.

Mascara

Thick liquid (normally brown or black, but available in

other colors) that is used to thicken and lengthen the eyelashes. Applied with a brush.

Masque

Cleansing product that is applied to the face and allowed to dry to draw dirt and oils out of the pores. Some masques rinse off, others are peeled off.

Medicated cream

Product used to help clear up and prevent pimples, blackheads and other skin problems. Removes oils and bacteria that can lead to breakouts. Also called acne cream.

Moisturizer

Cream product used to rehydrate the skin and smooth dry and/or flaky patches.

Nail polish

Colored liquid brushed onto fingernails and/or toenails. For most photographic purposes, a light or neutral color is most desirable.

Normal skin

Skin that does not tend to be overly oily or dry, or displays a combination of oily and dry areas.

Oily skin

Skin which tends to produce excess oil and appear shiny. May require extra cleansing to maintain a clean and clear appearance.

Pedicure

Regular cleaning, trimming, filing and polishing of the toenails (and surrounding area) to maintain an appealing appearance.

Plucking

Removal of unwanted stray hairs using tweezers. A common way of shaping the eyebrows.

Powder brush

Large soft brush used to apply powder to the face and/or body.

Powder (loose)

Used to set foundation and concealers, and reduce the shiny look of oil-based make-up or the gloss of oily skin. Loose powder is the type used by most people and is applied with a soft powder puff, then blended.

Powder (pressed)

Used to set foundation and concealers, and reduce the shiny look of oil-based make-up or the gloss of oily skin. Comes in a cake form in a compact.

Powder (wet-dry)

Used to set foundation and concealers, and reduce the shiny look of oil-based make-up or the gloss of oily skin. Also used when more coverage (than that of a loose powder) is desired, or when using the powder a foundation. When using wet-dry powder as foundation, select a color close to the model's skin tone.

Powder puff

Large soft puff used to apply powder to the face and/or body.

Rouge

Colored product most often applied on the cheeks, but with occasional applications elsewhere on the face. *See* Blush.

Scrub

Product used to deeply clean and exfoliate the skin.

Shader

Make-up product that is slightly darker than the model's skin tone and is applied to de-accentuate particular features or areas of the face.

Shaving

Use of a razor to remove unwanted body hairs. Many models carry a razor for quick touch-ups.

Skin color

Overall coloration of skin (from light, to olive, to dark and everything in between) to which foundation, concealer and powder must be matched. Models with tan lines may require more than one color of make-up to achieve an even skin tone.

Skin type

General tendency of the skin to be oily, dry, normal or combination.

Sponges (cosmetic)

Small sponges (often triangle-shaped) used to apply and blend make-up (particularly foundation).

Sunscreen

Product used to reduce skin's exposure to sun damage. Use of sunscreen on the face, but not the neck or other body parts, may result in uneven skin tone that requires some work with foundation to conceal.

Tanning cream

Colored cream which, when applied to the body, simulates the tone of a tan without exposing the skin to damage from the sun.

Toner

Product used to neutralize the pH of the skin and create a firm, even, more toned texture.

Top coat

A clear, protective product brushed onto nails after applying nail polish.

Tweezers

Device used to remove stray hairs.

Waxing

Process used to remove unwanted hair. Hot wax is applied to an area and covered with a paper strip. When the wax is cooled, and the paper and wax are pulled away, the hair is removed from the area. Provides longer-lasting hair removal than shaving.

INDEX

G
Gauze, 35
Glasses, 88
Glitter, 88

H
Hair
 bleaching, 28
 body
 color, 16
 facial, 28
 removal, 28, 83
 style, 16
Hands, 81, 85-86
 fingernails, 85-86
Hats, 16, 88
Head sheets, 16-17
Highlighter
 cheekbones, 45
 eyes, 45
 lips, 45
 powder, 44-45
Hot pack, 35
Hypoallergenic
 products, 27,79

I
Insect sting treatment, 35

J
Jewelry, 16, 88

L
Lemon juice, 27
Lighting, 13, 16
Lip color
 application, 54-55
 choosing, 49-50
 testing, 49-50
 lip cream, 51
 lip gloss, 54
 lip matte, 54
 lip pencil, 54
 lip stain, 51-52
 lipstick, 51
 removal, 55

M
Make-up remover, 21, 34
Mascara, 63
 application, 63
 color selection, 53
Matches, 35
Mirror
 hand, 32
 working, 32
Models
 children, 18-19
 professional, 17
Moisturizer, 35, 79

N
Nail cutter, 33
Nasal spray, 35
Normal skin, 24

O
Oily skin, 24

P
Pedicure, 85
Pimples, 27-28
Plastic surgery, 28, 79
Plucking, 28
Polaroid, 17
Pores,
 cleansing strips, 22
 clogged, 20, 22
Portfolios, 17
Powder puffs, 32
Powders
 application, 46
 color selection, 45
 in place of
 foundation, 45
 loose, 45-46
 pressed, 45-46
 wet-dry, 45-46
Props, 16, 88

R
Rashes, 20, 27-28, 79
Razors, electric, 83

Other Books from
Amherst Media™

Basic 35mm Photo Guide,
5th Edition
Craig Alesse

Great for beginning photographers! Designed to teach 35mm basics step-by-step — completely illustrated. Features the latest cameras. Includes: 35mm automatic, semi-automatic cameras, camera handling, *f*-stops, shutter speeds, and more! $12.95 list, 9x8, 112p, 178 photos, order no. 1051.

Big Bucks Selling Your
Photography, *2nd Edition*
Cliff Hollenbeck

A completly updated photo business package. Includes starting up, getting pricing, creating successful portfolios and using the internet as a tool! Features setting financial, marketing and creative goals. Organize your business planning, bookkeeping, and taxes. $17.95 list, 8½, 128p, 30 photos, b&w, order no. 1177.

Build Your Own Home
Darkroom
Lista Duren & Will McDonald

This classic book teaches you how to build a high quality, inexpensive darkroom in your basement, spare room, or almost anywhere. Includes valuable information on: darkroom design, woodworking, tools, and more! $17.95 list, 8½x11, 160p, 50 photos, many illustrations, order no. 1092.

Outdoor and Location
Portrait Photography
Jeff Smith

Learn how to work with natural light, select locations, and make clients look their best. Step-by-step discussions and helpful illustrations teach you the techniques you need to shoot outdoor portraits like a pro! $29.95 list, 8½x11, 128p, 60+ b&w and color photos, index, order no. 1632.

Into Your Darkroom
Step-by-Step
Dennis P. Curtin

This is the ideal beginning darkroom guide. Easy to follow and fully illustrated each step of the way. Includes information on: the equipment you'll need, set-up, making proof sheets and much more! $17.95 list, 8½x11, 90p, hundreds of photos, order no. 1093.

Make Money with
Your Camera
David Neil Arndt

Learn everything you need to know in order to make money in photography! David Arndt shows how to take highly marketable pictures, then promote, price and sell them. Includes all major fields of photography. $29.95 list, 8½x11, 120p, 100 b&w photos, index, order no. 1639.

Wedding Photographer's
Handbook
Robert and Sheila Hurth

A complete step-by-step guide to succeeding in the world of wedding photography. Packed with shooting tips, equipment lists, must-get photo lists, business strategies, and much more! $24.95 list, 8½x11, 176p, index, 100 b&w and color photos, diagrams, order no. 1485.

Leica Camera Repair
Handbook
Thomas Tomosy

A detailed technical manual for repairing Leica cameras. Each model is discussed individually with step-by-step instructions. Exhaustive photographic illustration ensures that every step of the process is easy to follow. $39.95 list, 8½x11, 128p, 130 b&w photos, appendix, order no. 1641.

Lighting for People
Photography, *2nd Edition*
Stephen Crain

The up-to-date guide to lighting. Includes: set-ups, equipment information, strobe and natural lighting, and much more! Features diagrams, illustrations, and exercises for practicing the techniques discussed in each chapter. $29.95 list, 8½x11, 120p, 80 b&w and color photos, glossary, index, order no. 1296.

Guide to International
Photographic
Competitions
Dr. Charles Benton

Remove the mystery from international competitions with all the information you need to select competitions, enter your work, and use your results for continued improvement and further success! $29.95 list, 8½x11, 120p, 60 b&w photos, index, appendices, order no. 1642.

Freelance Photographer's Handbook

Cliff & Nancy Hollenbeck

Whether you want to be a freelance photographer or are looking for tips to improve your current freelance business, this volume is packed with ideas for creating and maintaining a successful freelance business. $29.95 list, 8½x11, 107p, 100 b&w and color photos, index, glossary, order no. 1633.

Infrared Landscape Photography

Todd Damiano

Landscapes shot with infrared can become breathtaking images. The author analyzes over fifty of his most compelling photographs to teach you the techniques you need to capture landscapes with infrared. $29.95 list, 8½x11, 120p, 60 b&w photos, index, order no. 1636.

Wedding Photography:
Creative Techniques for Lighting and Posing, *2nd Edition*

Rick Ferro

Creative techniques for lighting and posing wedding portraits that will set your work apart from the competition. Covers every phase of wedding photography. $29.95 list, 8½x11, 128p, full color photos, index, order no. 1649.

Professional Secrets of Advertising Photography

Paul Markow

No-nonsense information for those interested in the business of advertising photography. Includes: how to catch the attention of art directors, make the best bid, and produce the high-quality images your clients demand. $29.95 list, 8½x11, 128p, 80 photos, index, order no. 1638.

Lighting Techniques for Photographers

Norman Kerr

This book teaches you to predict the effects of light in the final image. It covers the interplay of light qualities, as well as color compensation and manipulation of light and shadow. $29.95 list, 8½x11, 120p, 150+ color and b&w photos, index, order no. 1564.

Infrared Photography Handbook

Laurie White

Covers black and white infrared photography: focus, lenses, film loading, film speed rating, batch testing, paper stocks, and filters. Black & white photos illustrate how IR film reacts. $29.95 list, 8½x11, 104p, 50 b&w photos, charts & diagrams, order no. 1419.

How to Shoot and Sell Sports Photography

David Arndt

A step-by-step guide for amateur photographers, photojournalism students and journalists seeking to develop the skills and knowledge necessary for success in the demanding field of sports photography. $29.95 list, 8½x11, 120p, 111 photos, index, order no. 1631.

How to Operate a Successful Photo Portrait Studio

John Giolas

Combines photographic techniques with practical business information to create a complete guide book for anyone interested in developing a portrait photography business (or improving an existing business). $29.95 list, 8½x11, 120p, 120 photos, index, order no. 1579.

Fashion Model Photography

Billy Pegram

For the photographer interested in shooting commercial model assignments, or working with models to create portfolios. Includes techniques for dramatic composition, posing, selection of clothing, and more! $29.95 list, 8½x11, 120p, 58 photos, index, order no. 1640.

Computer Photography Handbook

Rob Sheppard

Learn to make the most of your photographs using computer technology! From creating images with digital cameras, to scanning prints and negatives, to manipulating images, you'll learn all the basics of digital imaging. $29.95 list, 8½x11, 128p, 150+ photos, index, order no. 1560.

Achieving the Ultimate Image

Ernst Wildi

Ernst Wildi teaches the techniques required to take world class, technically flawless photos. Features: exposure, metering, the Zone System, composition, evaluating an image, and more! $29.95 list, 8½x11, 128p, 120 b&w and color photos, index, order no. 1628.

Black & White Portrait Photography

Helen T. Boursier

Make money with b&w portrait photography. Learn from top b&w shooters! Studio and location techniques, with tips on preparing your subjects, selecting settings and wardrobe, lab techniques, and more! $29.95 list, 8½x11, 128p, 130+ photos, index, order no. 1626

Stock Photography

Ulrike Welsh

This book provides an inside look at the business of stock photography. Explore photographic techniques and business methods that will lead to success shooting stock photos — creating both excellent images and business opportunities. $29.95 list, 8½x11, 120p, 58 photos, index, order no. 1634.

Profitable Portrait Photography

Roger Berg

A step-by-step guide to making money in portrait photography. Combines information on portrait photography with detailed business plans to form a comprehensive manual for starting or improving your business. $29.95 list, 8½x11, 104p, 100 photos, index, order no. 1570

Professional Secrets for Photographing Children

Douglas Allen Box

Covers every aspect of photographing children on location and in the studio. Prepare children and parents for the shoot, select the right clothes capture a child's personality, and shoot story book themes. $29.95 list, 8½x11, 128p, 74 photos, index, order no. 1635.

Handcoloring Photographs Step-by-Step

Sandra Laird & Carey Chambers

Learn to handcolor photographs step-by-step with the new standard in handcoloring reference books. Covers a variety of coloring media and techniques with plenty of colorful photographic examples. $29.95 list, 8½x11, 112p, 100+ color and b&w photos, order no. 1543.

Swimsuit Model Photography

Cliff Hollenbeck

The complete guide to the business of swimsuit model photography. Includes: finding and working with models, selecting equipment, posing, using props and backgrounds, and more! $29.95 list, 8½x11, 112p, over 100 b&w and color photos, index, order no. 1605.

Fine Art Portrait Photography

Oscar Lozoya

The author examines a selection of his best photographs, and provides detailed technical information about how he created each. Lighting diagrams accompany each photograph. $29.95 list, 8½x11, 128p, 58 photos, index, order no. 1630.

Family Portrait Photography

Helen Boursier

Learn from professionals how to operate a successful portrait studio. Includes: marketing family portraits, advertising, working with clients, posing, lighting, and selection of equipment. Includes images from a variety of top portrait shooters. $29.95 list, 8½x11, 120p, 123 photos, index, order no. 1629.

The Art of Infrared Photography, *4th Edition*

Joe Paduano

Practical guide to the art of infrared photography. Tells what to expect and how to control results. Includes: anticipating effects, color infrared, digital infrared, using filters, focusing, developing, printing, handcoloring, toning, and more! $29.95 list, 8½x11, 112p, 70 photos, order no. 1052

The Art of Portrait Photography

Michael Grecco

Michael Grecco reveals the secrets behind his dramatic portraits which have appeared in magazines such as *Rolling Stone* and *Entertainment Weekly*. Includes: lighting, posing, creative development, and more! $29.95 list, 8½x11, 128p, 60 photos, order no. 1651.

Photographer's Guide to Polaroid Transfer

Christopher Grey

Step-by-step instructions make it easy to master Polaroid transfer and emulsion lift-off techniques and add new dimensions to your photographic imaging. Fully illustrated every step of the way to ensure good results the very first time! $29.95 list, 8½x11, 128p, 50 photos, order no. 1653.

Black & White Landscape Photography

John Collett and David Collett

Master the art of b&w landscape photography. Includes: selecting equipment (cameras, lenses, filters, etc.) for landscape photography, shooting in the field, using the Zone System, and printing your images for professional results. $29.95 list, 8½x11, 128p, 80 b&w photos, order no. 1654.

Wedding Photojournalism

Andy Marcus

Learn the art of creating dramatic unposed wedding portraits. Working through the wedding from start to finish you'll learn where to be, what to look for and how to capture it on film. A hot technique for contemporary wedding albums! $29.95 list, 8½x11, 128p, b&w, over 50 photos, order no. 1656.

Studio Portrait Photography of Children and Babies

Marilyn Sholin

Learn to work with the youngest portrait clients to create images that will be treasured for years to come. Includes tips for working with kids at every developmental stage, from infant to pre-schooler. Features: lighting, posing and much more! $29.95 list, 8½x11, 128p, 60 photos, order no. 1657.

Professional Secrets of Wedding Photography

Douglas Allen Box

Top-quality portraits are individually analyzed to teach you the art of professional wedding portraiture. Lighting diagrams, posing information and technical specs are included for every image. $29.95 list, 8½x11, 128p, order no. 1658.

Photographer's Guide to Shooting Model & Actor Portfolios

CJ Elfont, Edna Elfont and Alan Lowy

Learn to create outstanding images for actors and models looking for work in fashion, theater, television, or the big screen. Includes the business, photographic and professional information you need to succeed! $29.95 list, 8½x11, 128p, 100 photos, order no. 1659.

Photo Retouching with Adobe® Photoshop®

Gwen Lute

Designed for photographers, this manual teaches every phase of the process, from scanning to final output. Learn to restore damaged photos, correct imperfections, create realistic composite images and correct for dazzling color. $29.95 list, 8½x11, 120p, 60+ photos, order no. 1660.

Creative Lighting Techniques for Studio Photographers

Dave Montizambert

Master studio lighting and gain complete creative control over your images. Whether you are shooting portraits, cars, table-top or any other subject, Dave Montizambert teaches you the skills you need to confidently create with light. $29.95 list, 8½x11, 120p, 80+ photos, order no. 1666.

Storytelling Wedding Photography

Barbara Box

Barbara and her husband shoot as a team at weddings. Here, she shows you how to create outstanding candids (which are her specialty), and combine them with formal portraits (her husband's specialty) to create a unique wedding album. $29.95 list, 8½x11, 128p, 60 b&w photos, order no. 1667.

Fine Art Children's Photography

Doris Carol Doyle and Ian Doyle

Learn to create fine art portraits of children in black & white. Included is information on: posing, lighting for studio portraits, shooting on location, clothing selection, working with kids and parents, and much more! $29.95 list, 8½x11, 128p, 60 photos, order no. 1668.

Infrared Portrait Photography

Richard Beitzel

Discover the unique beauty of infrared portraits, and learn to create them yourself. Included is information on: shooting with infrared, selecting subjects and settings, filtration, lighting, and much more! $29.95 list, 8½x11, 128p, 60 b&w photos, order no. 1669.

Black & White Photography for 35mm

Richard Mizdal

A guide to shooting and darkroom techniques! Perfect for beginning or intermediate photographers who want to improve their skills. Features helpful illustrations and exercises to make every concept clear and easy to follow. $29.95 list, 8½x11, 128p, 100+ b&w photos, order no. 1670.

Marketing and Selling Black & White Portrait Photography

Helen T. Boursier

A complete manual for adding b&w portraits to the products you offer clients (or offering exclusively b&w photography). Learn how to attract clients and deliver the portraits that will keep them coming back. $29.95 list, 8½x11, 128p, 50+ photos, order no. 1677.

Innovative Techniques for Wedding Photography

David Neil Arndt

Spice up your wedding photography (and attract new clients) with dozens of creative techniques from top-notch professional wedding photographers! $29.95 list, 8½x11, 120p, 60 photos, order no. 1684.

Infrared Wedding Photography

Patrick Rice, Barbara Rice & Travis Hill

Step-by-step techniques for adding the dreamy look of black & white infrared to your wedding portraiture. Capture the fantasy of the wedding with unique ethereal portraits your clients will love! $29.95 list, 8½x11, 128p, 60 images, order no. 1681.

Photographing Children in Black & White

Helen T. Boursier

Learn the techniques professionals use to capture classic portraits of children (of all ages) in black & white. Discover posing, shooting, lighting and marketing techniques for black & white portraiture in the studio or on location. $29.95 list, 8½x11, 128p, 100 photos, order no. 1676.

Dramatic Black & White Photography:
Shooting and Darkroom Techniques

J.D. Hayward

Create dramatic fine-art images and portraits with the master b&w techniques in this book. From outstanding lighting techniques to top-notch, creative darkroom work, this book takes b&w to the next level! $29.95 list, 8½x11, 128p, order no. 1687.

Photographing Your Artwork

Russell Hart

A step-by-step guide for taking high-quality slides of artwork for submission to galleries, magazines, grant committees, etc. Learn the best photographic techniques to make your artwork (be it 2D or 3D) look its very best! $29.95 list, 8½x11, 128p, 80 b&w photos, order no. 1688.

Posing and Lighting Techniques for Studio Portrait Photographers

J.J. Allen

Master the skills you need to create beautiful lighting for portraits of any subject. Posing techniques for flattering, classic images help turn every portrait into a work of art. $29.95 list, 8½x11, 120p, 125 fullcolor photos, order no. 1697.

Studio Portrait Photography in Black & White

David Derex

From concept to presentation, you'll learn how to select clothes, create beautiful lighting, prop and pose top-quality black & white portraits in the studio. $29.95 list, 8½x11, 128p, 70 photos, order no. 1689.

Watercolor Portrait Photography:
The Art of Manipulating Polaroid SX-70 Images

Helen T. Boursier

Create one-of-a-kind images with this surprisingly easy artistic technique. $29.95 list, 8½x11, 120p, 200+ color photos, order no. 1698.

Techniques for Black & White Photography: Creativity and Design

Roger Fremier

Harness your creativity and improve your photographic design with these techniques and exercises. From shooting to editing your results, it's a complete course for photographers who want to be more creative. $19.95 list, 8½x11, 112p, 30 photos, order no. 1699.

Corrective Lighting and Posing Techniques for Portrait Photographers

Jeff Smith

Learn to make every client look his or her best by using lighting and posing to conceal real or imagined flaws – from baldness, to acne, to figure flaws. $29.95 list, 8½x11, 120p, full color, 150 photos, order no. 1711.